林湖奎繪著

海水魚 ● 熱帶魚
Drawing Sea Fish & Tropical Fish

by Lin Hu-Kuei

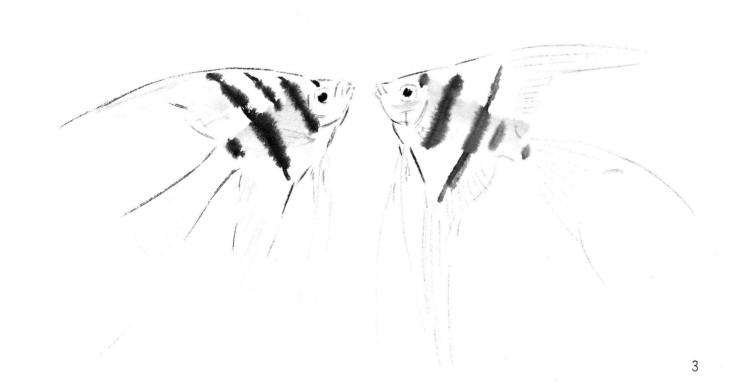

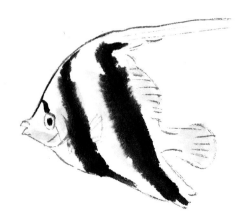

Drawing Sea Fish & Tropical Fish
by Lin Hu-Kuei

English Editor: Yen-chen Hsu
Chinese Editor: Ong Shee Ho!
Publisher: Ho Kung-shang
Published by ART Book Co., Ltd.

First Edition: 1989
All Right Reserved

Address: NO. 18, LANE 283, ROOSEVELT ROAD, SEC. 3,
TAIPEI, TAIWAN, R.O.C.
TEL: (02) 2362-0578 • 2362-9769
FAX: (02) 2362-3594

Price: US
Printed in Taiwan

海水魚・熱帶魚
Drawing Sea Fish & Tropical Fish

目錄 Contents

畫魚樂

兼介林湖奎筆下的魚

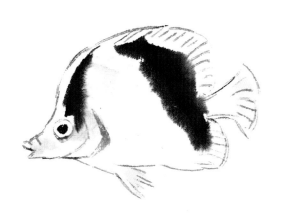

微風吹拂，水上碧草蕩漾，花瓣灑落，隨流水緩緩遠去；魚兒托出水面，靜靜的春水頓時激起層層漣漪。

這等優美的意境似乎似曾相識；的確，正如詩句「風微不動草，紅雨灑花津。跳波魚出藻，攪碎一池春。」林湖奎曾經描繪的金魚錦鯉天地，便是如此悠遠清揚。

如今，畫家的筆鋒一轉，再將人們帶離滾滾世俗紅塵的亂流，隨著群群熱帶魚，游向寬潤清涼的精神世界。

唐代詩人寫禪境與幽隱，多用山林造境；而宋詞和元曲中的道家情調，則是以水造境，畫家亦復如此，因而創造了許多遠離塵囂、孤境冷傲的境界。

詩詞著眼於漁夫山樵傍水依山時的心靈感應，以閱讀詩詞的心情來欣賞林湖奎筆下的游魚，便能發現：詩詞、繪畫竟是殊途同歸，詩人、畫家以旁觀者清醒的眼光，靜觀人生世態演變的軌跡，帶領欣賞者避開心靈的污染，回到人生單純的起點，對入世的生涯，產生冲淡與平衡作用。

但如果真要深究詩、畫的表現境界之異同，或許可以這麼說：詩詞抒發了隱於山林裏的人們真我面貌；而畫家借物傳情，表達了隱於紅塵的超逸飄灑。林湖奎選擇色彩斑爛炫麗的熱帶魚為移情的對象，游魚的鎮定從容、任性自如，顯現了更為寬朗開潤的天地，正也隱含了這種「大隱」的超拔精神呢！

做為嶺南畫派的傳承者，林湖奎一方面必須汲取前人的經驗，加以發揚光大，一方面還得掙脫流派的形骸，研創個人獨特的面貌。以熱帶魚為題材的創作，更能突顯他的決心與努力成果。

石濤在「畫語錄」的筆墨章中倡論，筆要融合於生活的體驗中，才能彰顯出傳神的效果；墨要「蒙養」方能產生靈秀的韻致，正是「墨之濺筆也以靈，筆之運墨也以神。墨非蒙養不靈，筆非生活不神。」林湖奎執取嶺南畫派強調寫生的功夫，使畫藝與生活打成一片，不僅磨練筆墨技法，同時涵養性靈，因此，他的畫風雖不似前人艷麗，輕筆淡墨之間，意蘊也隨之豐富美觀。

從表面看來，筆墨是有形的器物，但是，在有深厚蒙養與生活體驗深廣的林湖奎手中，信手一揮，寫生揣意、運情摹景，畫者的情懷意趣、賞畫者的遐思奇想，便隨著隻隻魚兒的游動而蕩漾於畫面了。

「筆墨本無情，不可使運筆墨者無情；作畫在攝情，不可使鑒畫者不生情。」林湖奎在形象生動的熱帶魚身上，融入了自己的感情，這是自然之美撥動了他的心弦；然後他以飽含情感的畫筆傳達這分感受，創造出一種既含蓄又鮮明的意境，魚兒獲得了充沛的生命泉源，使觀畫者很容易就產生共鳴。就情意表達這點而言，林湖奎也獲致了相當的成功。

水中游魚的世界，是可居可遊、是可以盡情暢懷的天地，林湖奎藉著多彩多姿的熱帶魚，再度將人們引向一個「借得幽居養性靈，靜中物態逼孤吟，匠心若累微鬚斷，剛博遊魚出水聽」的清幽境界。

至於千年來莊子與惠施爭辯「子非魚，焉如魚之樂？」或「子非魚，焉知魚之不樂？」的公案，留給哲學家思考；且讓我們捨棄世俗雜務的追逐競爭，隨小小魚兒同尋人生的桃花源吧！

黃寶萍

The Never Ending Joy — Lin Wu-kuei's Fish World

林湖奎簡介

林湖奎，廣東揭陽人，幼聰敏，嗜美術，及長畢業於美術專科學校，其後立雪於嶺南畫派大師趙少昂之門，深造研究，孜孜不息，卓然有成。近十年來在英、澳、台、韓、日、港、星、馬各地展出，凡十餘次，遐邇稱譽。

林湖奎先生追隨趙少昂大師逾十年，舉凡花卉，蟲色走獸，盡得其法，登其堂奧，其後卒由絢爛歸於平淡，力求突破，畫風與同窗學友，迥異其趣，論者多之。所繪竹雀、遊魚、白鶴、白鷺諸作，重視墨韻，講究線條，一反沒骨之法，賦色極其清雅脫俗，風格盡脫前人窠臼，而轉變嶺南畫派之形骸，頗予人清新雋永之感。

Lin Hu-Kuei was born in Chieh-yang city of Canton province, one of the south China's busiest and most prosperous province. He showed his talent of learning painting since his childhood. After graduating from a Fine Arts institute, he entered Chao Shao-ang's studio and continued his painting study. Mr. Chao is renowned as a master of the Lingnan school. Under Chao's instructions, Lin learned and specialized in a wide range of flower, insect, fish and animal paintings.

The over ten-year study under Mr. Chao paves the way for his future creation and development. In view of Lin's painting achievement, we find that he has already transcended the uses of brilliant colors and expressive brushwork, and the realistic depiction typical of the Lingnan school. In place of the characteristic Lingnan style, he develops his own style in terms of the application of lighter and milder colors, as well as the depiction of tropical fish. Concerning the painting subjects, he breaks away from the more pompous and brilliant painting subjects such as eagles, tigers, horses, etc., and prefers the rendition of sparrows, fish, cranes and egrets. In the execution of fish, especially, he creates a world of quietness and serenity evocative of a forever joy and place on pictorial surfaces.

Steps Guiding (1): Lining & Coloring
基本技法㈠：單魚鉤染

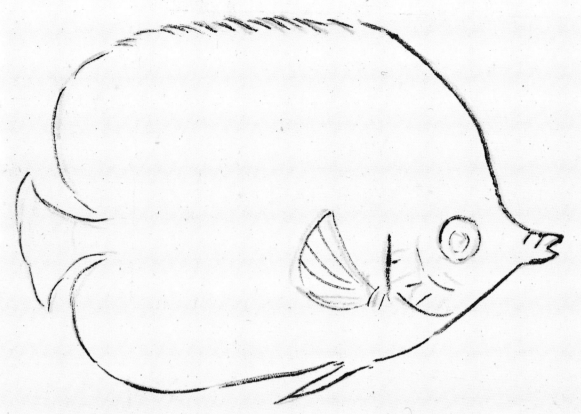

①先用小筆蘸淡墨勾出魚身，魚鰓、魚鰭、眼眶及頭部之輪廓，運中鋒筆。

Choose a thin brush to delineate the shape of fish with round strokes.

楊蟠蝶魚

分佈於溫帶至熱帶。身長20公分。主要特徵爲通眼黑線。背上後部有一黑點，這黑點在幼魚時代完全看不到。尖嘴寬扁身，看來似面可放在手裡把玩的扇子，靈巧可愛。

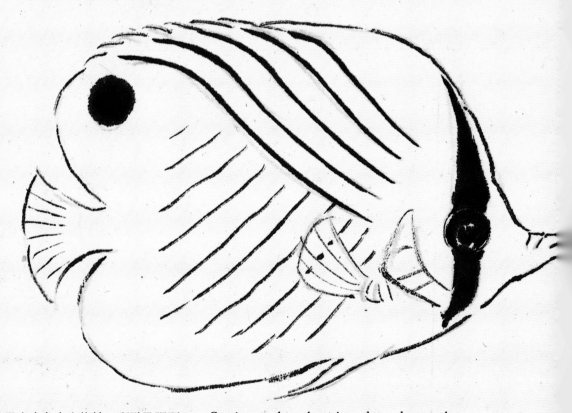

②用點梅筆蘸濃墨寫出魚身之條紋、斑點及眼眶。　Continue to draw the stripes, dot and eye socket.

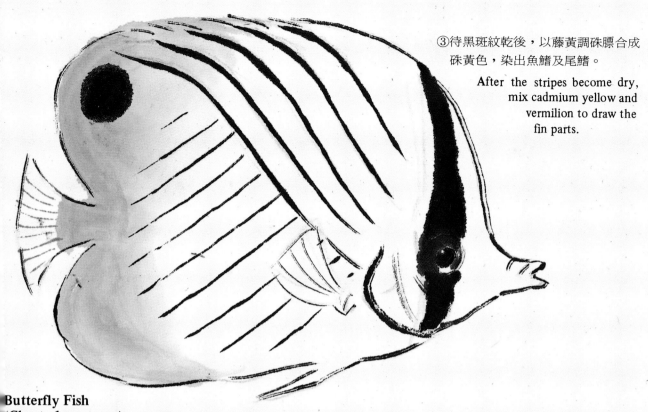

③待黑斑紋乾後，以藤黃調硃磦合成
硃黃色，染出魚鰭及尾鰭。

After the stripes become dry,
mix cadmium yellow and
vermilion to draw the
fin parts.

Butterfly Fish
(Chaetodon aureus)

These fish are fairly widespread through the tropical
and temperate zones. They usually measure in
length 20cm. The black stripes through the eyes
is their main characteristic.
There is a black spot on the back, but which only
shows up when they grow up fully.

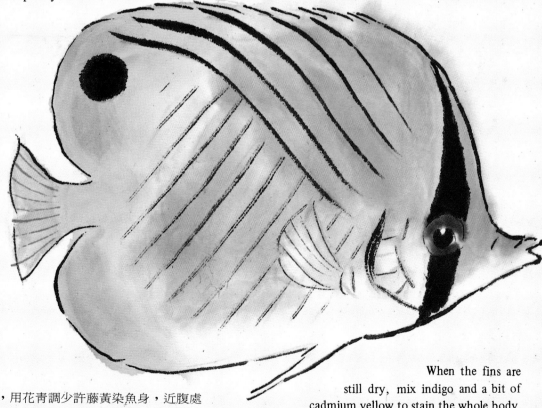

④趁顏色未乾透，用花青調少許藤黃染魚身，近腹處
染白色，頭部前端染草綠色（花青調石綠），最後點
睛完成。

When the fins are
still dry, mix indigo and a bit of
cadmium yellow to stain the whole body.
Dye white pigment on the abdomen, the mixture
of indigo and green on the front of head and eye.

①先用小筆蘸淡墨勾出魚身，魚鰓、魚鰭、眼眶及頭
　部之輪廓，運中鋒筆。

Mark the outline of the fish with round strokes.

八帶蝶魚

　　分佈於菲律賓以南的熱帶海域，在水槽內可長至10
公分；若在海洋則可達20公分。因其黃色身上的八條
黑色紋帶而得名。畫時須注意這八帶的分佈距離，有
近有遠，並不均一。

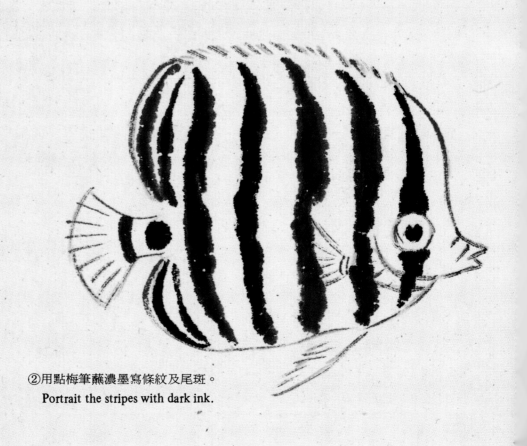

②用點梅筆蘸濃墨寫條紋及尾斑。

Portrait the stripes with dark ink.

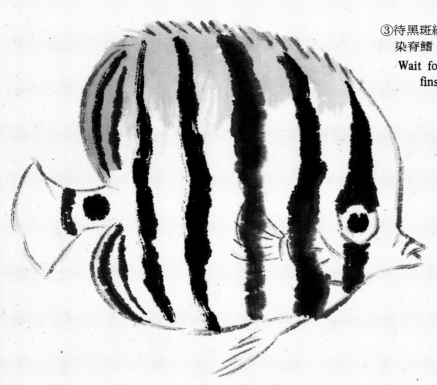

③待黑斑紋乾後，以花青調藤黃合成湖水綠色
染脊鰭。

Wait for the stripes dry completely, stain the
fins by the mixture of indgo and cadmium
yellow.

Butterfly Fish
(Chaetodon octofasciatus)

The fish are common in the tropical areas,
especially in the south of the Philippine
Islands. They usually measure in length
10cm when they are bred in aquariums
but 20cm in the ocean. Their name is derived
from the eight stripes on the body.

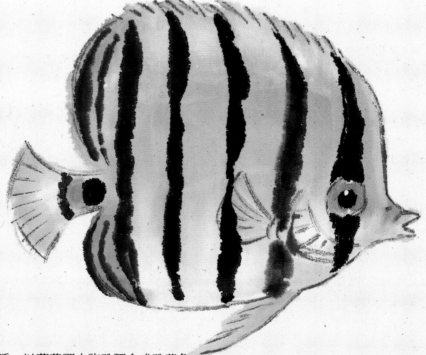

④趁脊鰭顏色未乾透，以藤黃調少許硃膘合成硃黃色
染魚身，近腹處染少許白色，眼眶加淺綠色，最後 點睛完成。

Use the mixed pigments of cadmium yellow
and a bit of vermilion to draw the whole
body, when the fins are still wet.

Dye a bit of white pigment on the abdomen.
Put some light green on the eye socket and
draw the pupil at last.

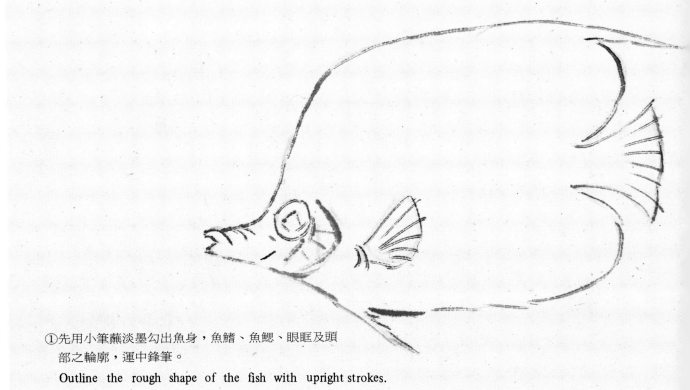

①先用小筆蘸淡墨勾出魚身，魚鰭、魚鰓、眼眶及頭
　部之輪廓，運中鋒筆。

Outline the rough shape of the fish with upright strokes.

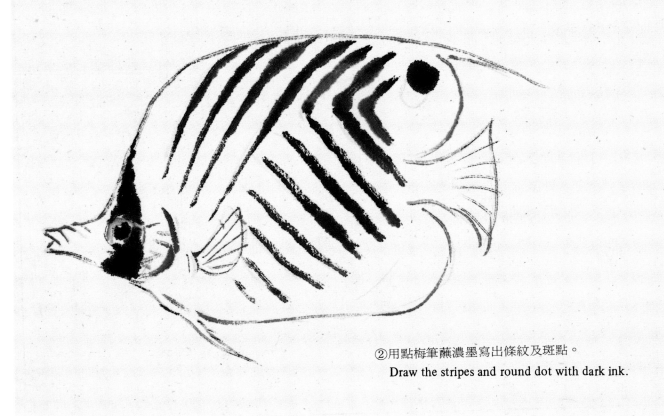

②用點梅筆蘸濃墨寫出條紋及斑點。

Draw the stripes and round dot with dark ink.

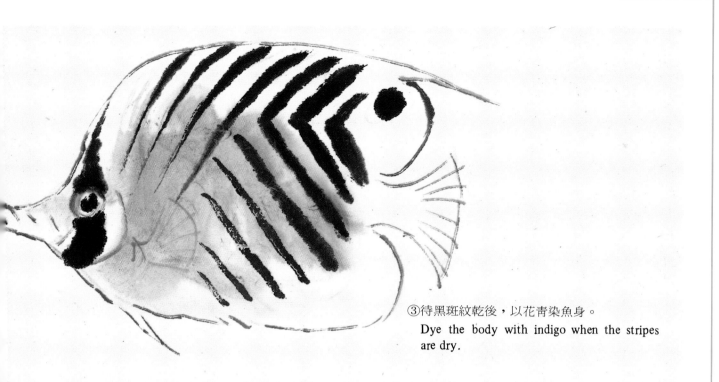

③待黑斑紋乾後，以花青染魚身。

Dye the body with indigo when the stripes are dry.

趁顏色未乾，以硃膘調藤黃成硃黃後，畫魚鰭及尾部，再用少許硃膘調白，染寫嘴和頭。魚腹用白色染上。

Use the mixture of vermilion and cadmium yellow to draw the fins and tail on the wet body. Draw the head and mouth with the mixture of a bit of vermilion and white pigment. Add some white strokes on abdomen.

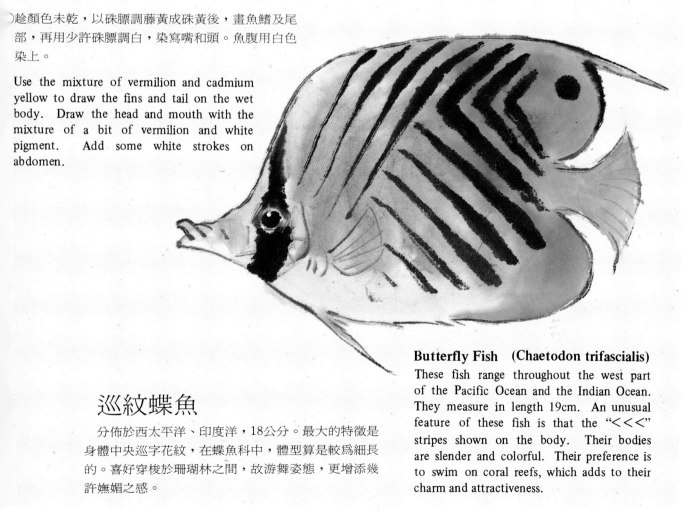

巡紋蝶魚

　　分佈於西太平洋、印度洋，18公分。最大的特徵是身體中央巡字花紋，在蝶魚科中，體型算是較爲細長的。喜好穿梭於珊瑚林之間，故游舞姿態，更增添幾許嫵媚之感。

Butterfly Fish (Chaetodon trifascialis)

These fish range throughout the west part of the Pacific Ocean and the Indian Ocean. They measure in length 19cm. An unusual feature of these fish is that the "<<<" stripes shown on the body. Their bodies are slender and colorful. Their preference is to swim on coral reefs, which adds to their charm and attractiveness.

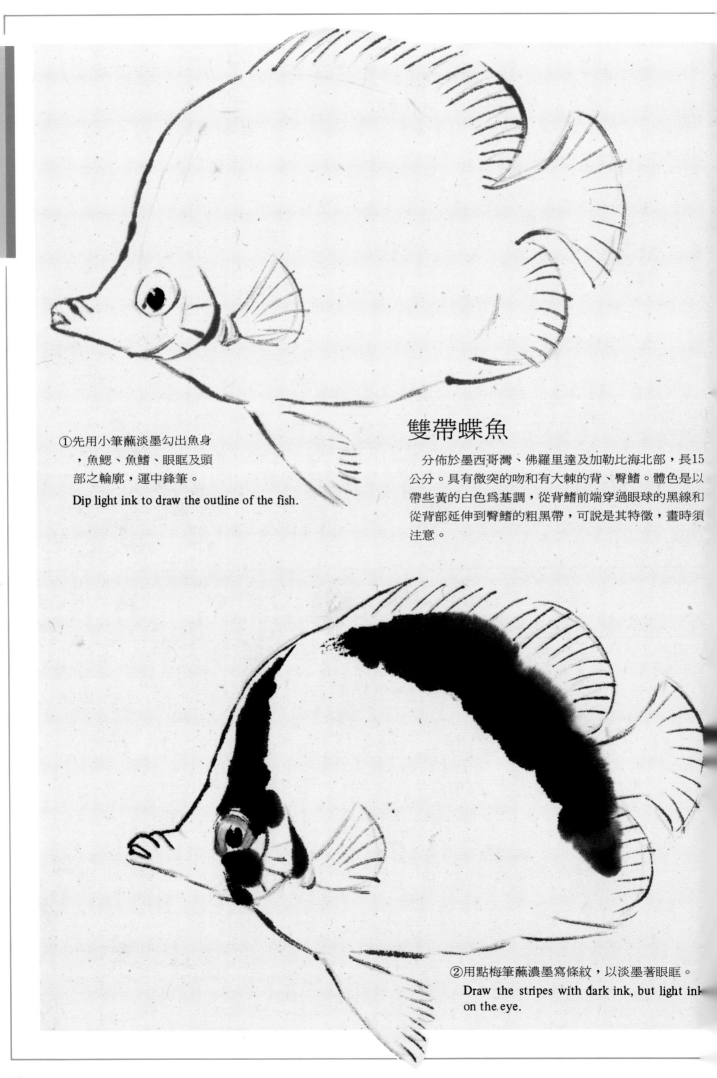

①先用小筆蘸淡墨勾出魚身
，魚鰓、魚鰭、眼眶及頭
部之輪廓，運中鋒筆。

Dip light ink to draw the outline of the fish.

雙帶蝶魚

　　分佈於墨西哥灣、佛羅里達及加勒比海北部，長15
公分。具有微突的吻和有大棘的背、臀鰭。體色是以
帶些黃的白色爲基調，從背鰭前端穿過眼球的黑線和
從背部延伸到臀鰭的粗黑帶，可說是其特徵，畫時須
注意。

②用點梅筆蘸濃墨寫條紋，以淡墨著眼眶。

**Draw the stripes with dark ink, but light ink
on the eye.**

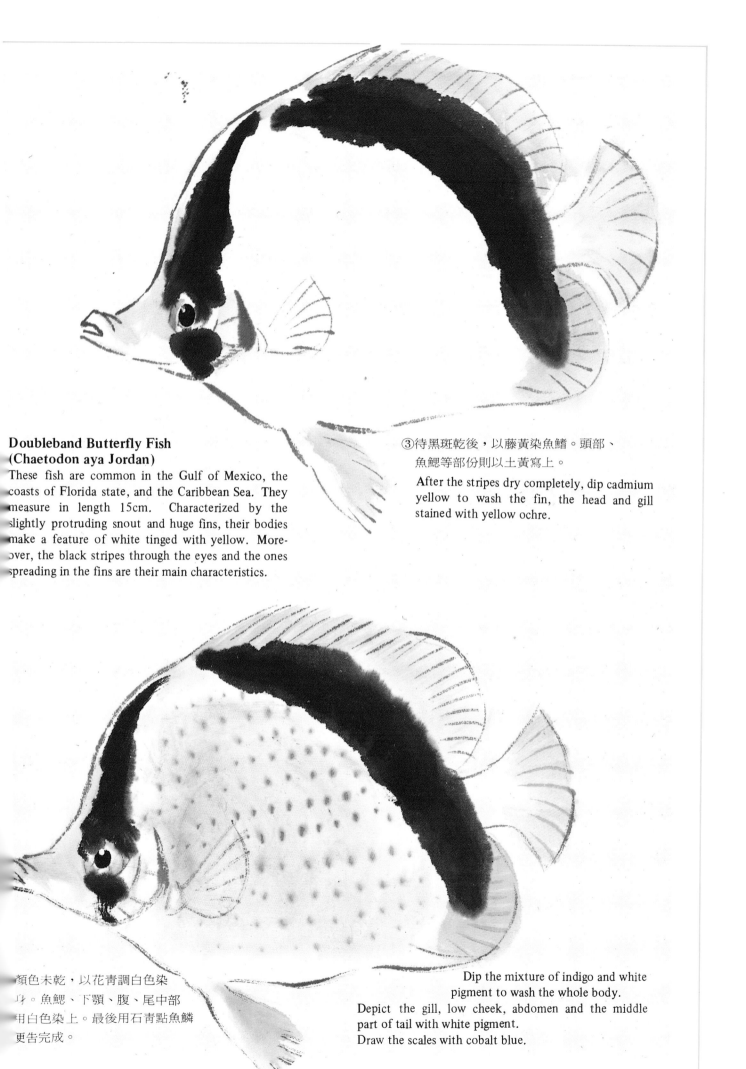

Doubleband Butterfly Fish
(Chaetodon aya Jordan)

These fish are common in the Gulf of Mexico, the coasts of Florida state, and the Caribbean Sea. They measure in length 15cm. Characterized by the slightly protruding snout and huge fins, their bodies make a feature of white tinged with yellow. Moreover, the black stripes through the eyes and the ones spreading in the fins are their main characteristics.

③待黑斑乾後，以藤黃染魚鰭。頭部、
魚鰓等部份則以土黃寫上。

After the stripes dry completely, dip cadmium yellow to wash the fin, the head and gill stained with yellow ochre.

顏色未乾，以花青調白色染
身。魚鰓、下顎、腹、尾中部
用白色染上。最後用石青點魚鱗
更告完成。

Dip the mixture of indigo and white pigment to wash the whole body.
Depict the gill, low cheek, abdomen and the middle part of tail with white pigment.
Draw the scales with cobalt blue.

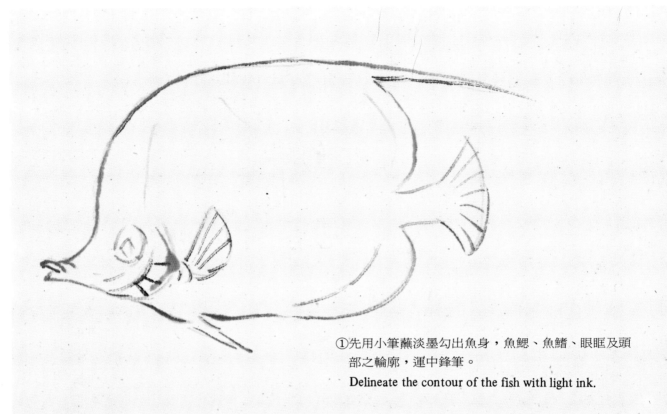

①先用小筆蘸淡墨勾出魚身，魚鰓、魚鰭、眼眶及頭部之輪廓，運中鋒筆。

Delineate the contour of the fish with light ink.

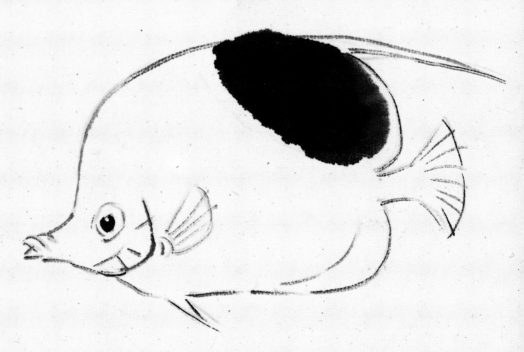

②用點梅筆蘸濃墨寫出魚身之墨斑。

Dip dark ink to draw the huge spot on the body.

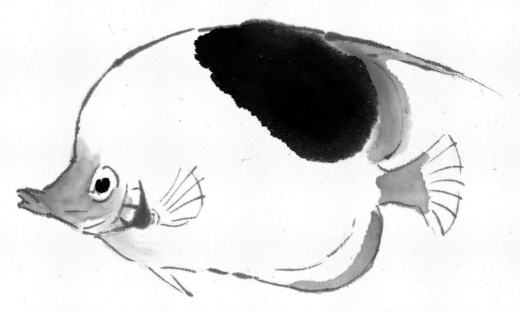

③待墨乾後，以赭石寫嘴部及魚鰭。
Wait for the spot dry totally, dip umber to draw the snout and the fin.

④趁顏色未乾，以花青調白染寫魚身及尾鰭，並畫上魚身條紋。以藍色加染眼眶，腹鰭加黃色。
Dip the mixture of indigo and white pigment to wash the body, tail and stripes.
Blue on the eye socket and yellow on the fin close to the abdomen.

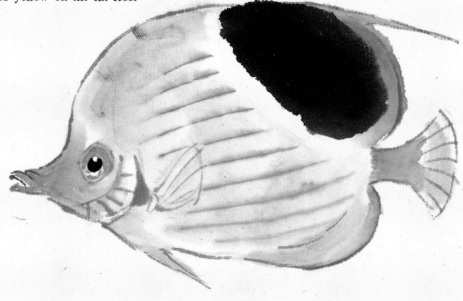

鞍背蝶魚

從東非到印度、斯里蘭卡的印度洋沿岸，皆爲其分佈區。全長20公分。體側背部黑色帶子的形狀呈三角形。尾柄的黑斑，是典型的帶狀。另外，體側橫條的數目是12～13條，繪寫時須注意其條紋的自然間隔。

Saddleback Butterfly Fish
(Chaetodon falcula bloch)
These fish are fairly widespread throughout the coasts of East Africa, India and Ceylon. They measure in length 20cm. The stripes on the side are ranged with the number of 12 or 13.

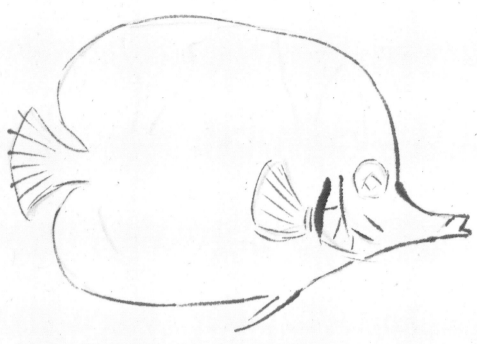

①先用小筆蘸淡墨勾出魚身，魚鰓、魚鰭、眼眶及頭
　部之輪廓，運中鋒筆。
Mark the rough shape of the fish.

黑背蝶魚

　　分佈廣泛，隨處可捕獲。體長30公分。主要特徵是
背部有一個大黑斑，但是只要仔細明察，又可看到黑、
藍、灰、黃、白、奶油、橙等色彩。成魚的背鰭很長，
吻部也是長而突出。色彩和體型，皆十分美麗，宜以
入畫。

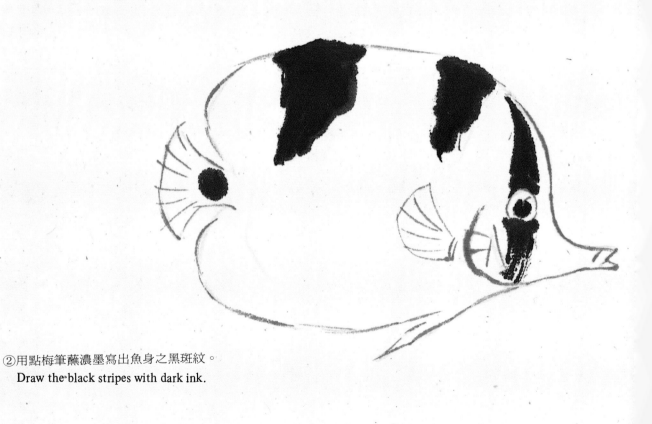

②用點梅筆蘸濃墨寫出魚身之黑斑紋。
Draw the black stripes with dark ink.

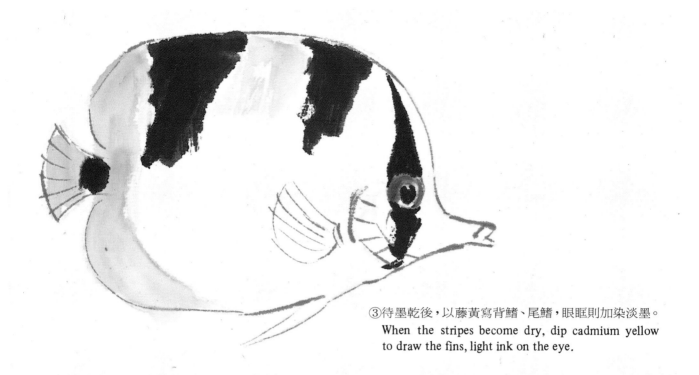

③待墨乾後，以藤黃寫背鰭、尾鰭，眼眶則加染淡墨。

When the stripes become dry, dip cadmium yellow to draw the fins, light ink on the eye.

Black Back Butterfly Fish
(Chaetodon ephippium)

They are widespread all over the world. They measure in length 30cm. The main characteristic besides in the huge black spot on the back. Taking a detailed look, we can observe that the spot is not completely black but tinged with blue, gray, yellow, white and orange.

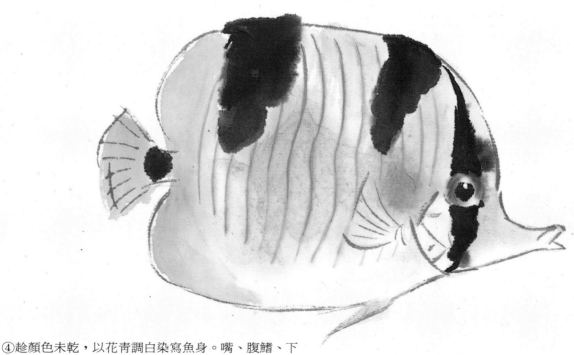

④趁顏色未乾，以花青調白染寫魚身。嘴、腹鰭、下顎、鰓、腹部等用白色染，魚身條紋用石青寫之。

Draw the body with the mixture of indigo and white pigment. Dye the white pigment on the snout, pelvic fin, low cheek, gill and abdomen. Dip cobalt blue to depict the stripes.

①先用小筆蘸墨勾出魚身，魚鰓、魚鰭、眼眶及頭部
　之輪廓，運中鋒筆。

Depict the outline of the fish.

②用羊毫筆蘸濃墨寫黑斑紋。

Use a soft-haired brush to draw the black spots with
dark ink.

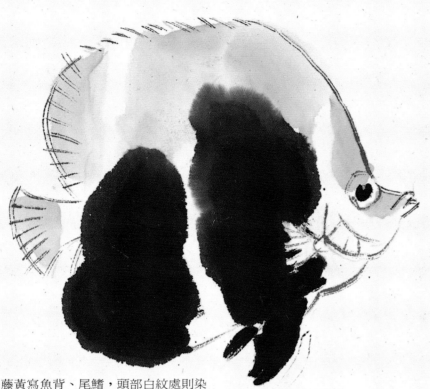

③待墨乾後，以藤黃寫魚背、尾鰭，頭部白紋處則染
　以白色。

After the pigment dry fully, dip cadmium yellow to depict the back and fin. Dye white pigment on the head.

④趁顏色未乾，以白色寫斑紋、腹部、魚鰓及嘴、下
　顎等。眼眶則加石綠色，最後點睛。

Dip white pigment to depict the stripe, abdomen, gill, mouth and low jaw. Add green on the eye socket.

側帶立旗鯛

棲息於有印度洋樂園之稱的馬爾地夫
至斯里蘭卡之間的海域。身長20公分
。臀鰭、腹鰭兩條連着身體的黑側帶
是其特徵。牠並不像其他立旗鯛般有
着長長的立旗狀背鰭，但身體却頗寬
大，呈梯形。悠游水中，顯得自在逍
遙。

Indian Ocean Bannerfish
(Heniochus pleurotaenia)

They flourish mainly in the ocean areas between Maldive Islands and Ceylon. They measure in length 20cm. The black stripes along the fins are their main characteristic.

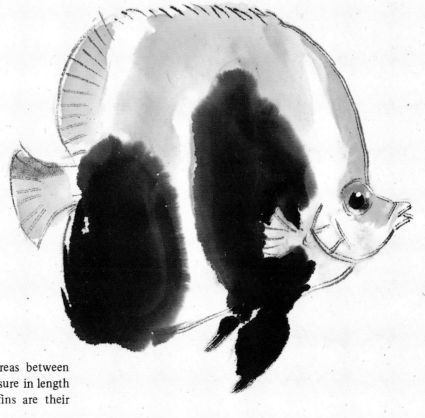

①先用小筆蘸淡墨勾出魚身，魚鰓、魚鰭、眼眶及頭
　部之輪廓，運中鋒筆。
Draw the rough shape of the fish.

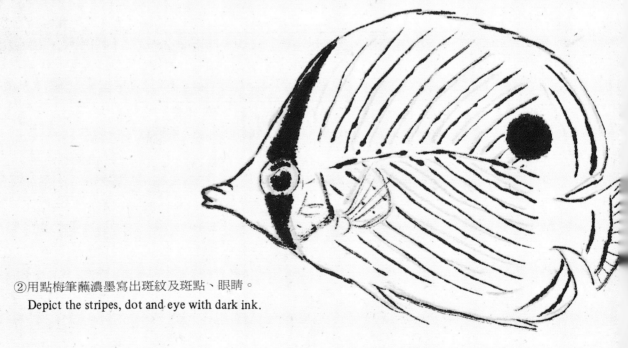

②用點梅筆蘸濃墨寫出斑紋及斑點、眼睛。
Depict the stripes, dot and eye with dark ink.

四目蝶魚

分佈於加勒比海、墨西哥灣、佛羅列達、百慕達
處。全長15公分。本種格調高，色彩美。幼魚期，
身體的中央及後部，有褐色的粗橫帶，尾柄部的大
斑上，另有一個像眼球般大的斑點。這些色彩會隨
魚的成長而消失，成魚時顏色純樸高貴。

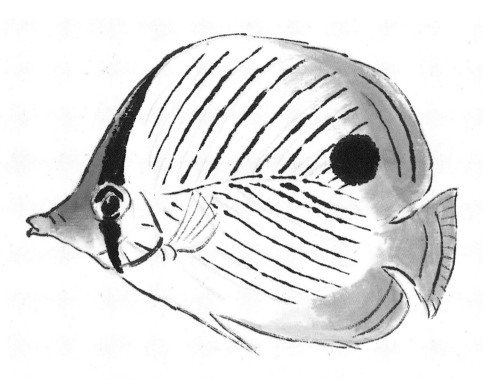

③待墨斑乾後，以花青調少許石綠染尾鰭，頭部色澤
略爲偏綠。

Dip the mixture of indigo and a bit of green to
draw the tail and head.

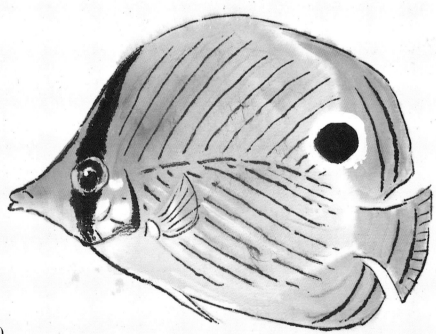

our-eye Butterfly Fish
haetodon Capistratus Linnaeus)

hese fish range throughout the Caribbean Sea,
e Gulf of Mexico and the coasts of Florida State.
hey measure in length 15 cm. When they are young,
ere are a huge stripe on the middle and back
rts of the body, as well as a large black spot on
e tail. When they grow up, those stripes and dots
sappear and the whole body appears brilliant and
tractive.

④趁顏色未乾透，用洋紅、少許花青調白色染魚身、
鰓、腹，下顎染白色，斑點邊加白色圓環，最後點
睛完成。

Use the mixed pigment of brilliant crimson, a bit
of indigo and white pigment to draw the body,
gill and abdomen, stain white pigment on the jaw
and eye.

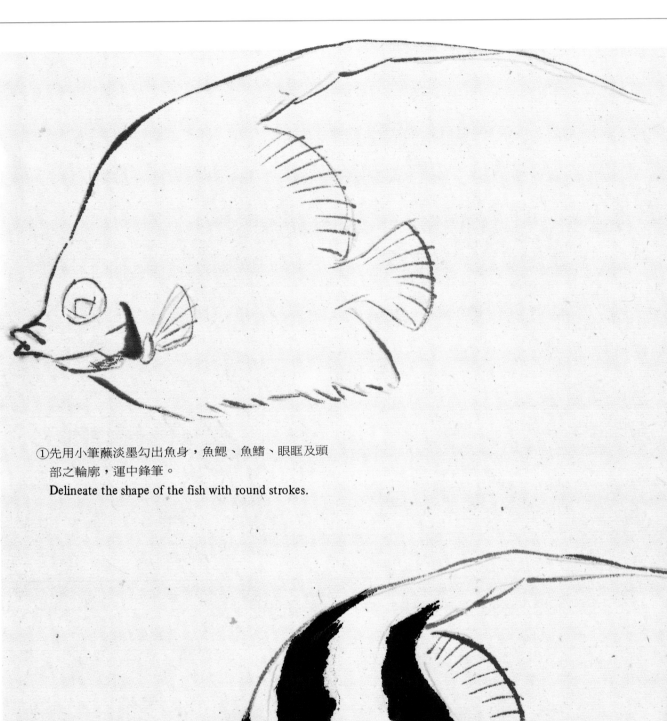

①先用小筆蘸淡墨勾出魚身，魚鰓、魚鰭、眼眶及頭部之輪廓，運中鋒筆。

Delineate the shape of the fish with round strokes.

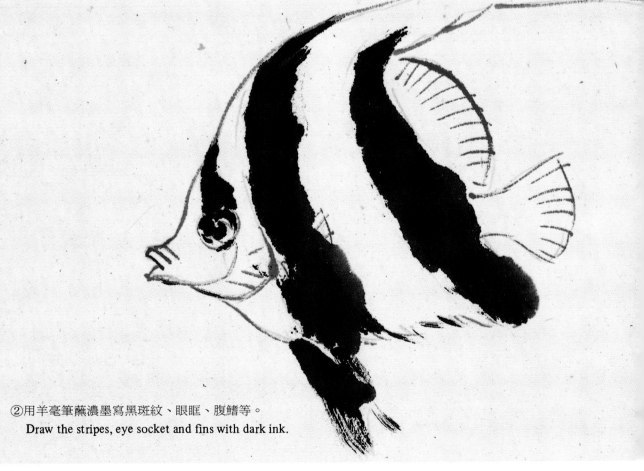

②用羊毫筆蘸濃墨寫黑斑紋、眼眶、腹鰭等。

Draw the stripes, eye socket and fins with dark ink.

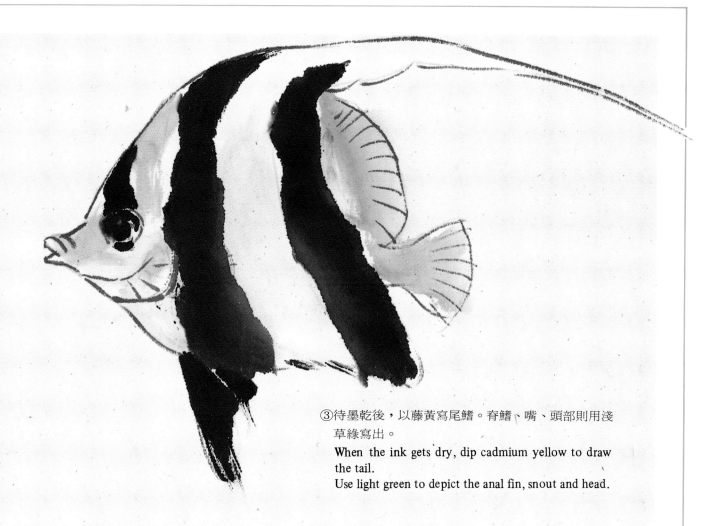

③待墨乾後，以藤黃寫尾鰭。脊鰭、嘴、頭部則用淺
草綠寫出。

When the ink gets dry, dip cadmium yellow to draw
the tail.
Use light green to depict the anal fin, snout and head.

④趁顏色未乾，以少許硃腰調白合成奶黃寫魚身，眼
眶加上淺綠色，並以淺綠點出鱗片，背鰭則加以染
白。

Use the mixed pigments of vermilion and
white pigment to draw the body, light
green on the eye socket and scales,
white pigment on dorsal fin.

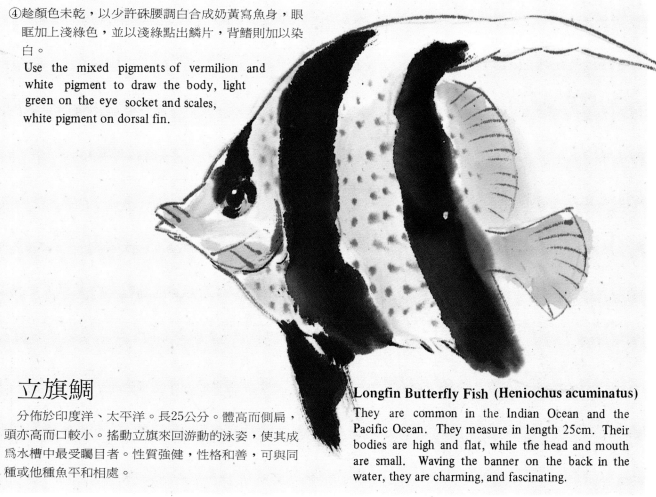

立旗鯛

　　分佈於印度洋、太平洋。長25公分。體高而側扁，
頭亦高而口較小。搖動立旗來回游動的泳姿，使其成
爲水槽中最受矚目者。性質強健，性格和善，可與同
種或他種魚平和相處。

Longfin Butterfly Fish (Heniochus acuminatus)

They are common in the Indian Ocean and the
Pacific Ocean. They measure in length 25cm. Their
bodies are high and flat, while the head and mouth
are small. Waving the banner on the back in the
water, they are charming, and fascinating.

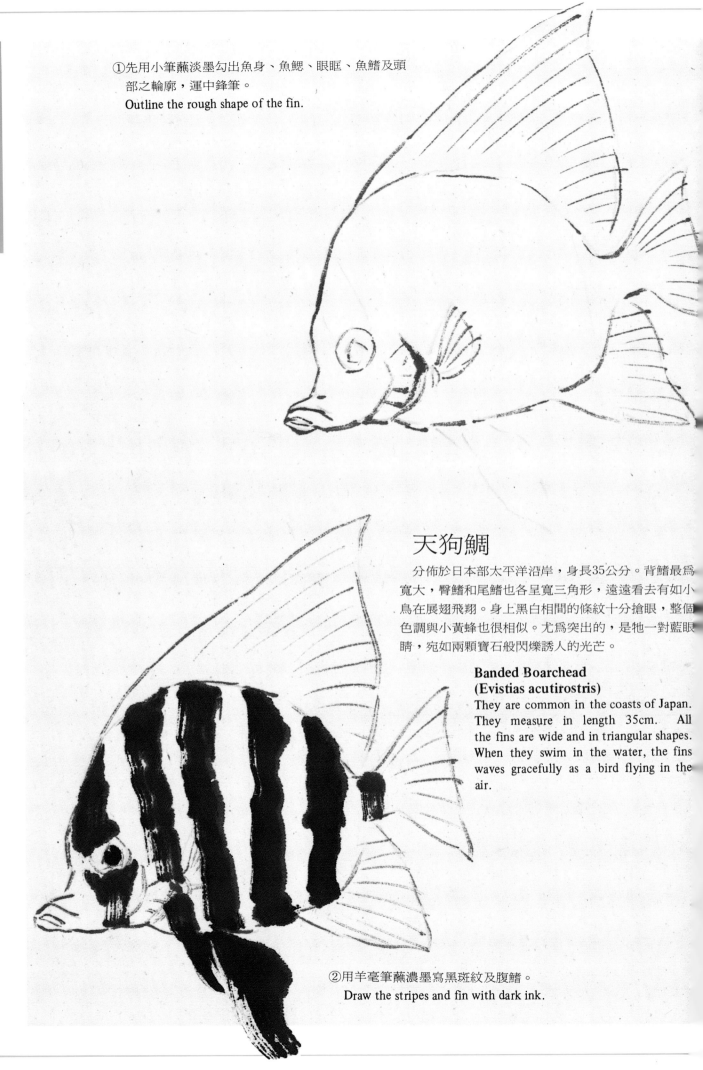

①先用小筆蘸淡墨勾出魚身、魚鰓、眼眶、魚鰭及頭
　部之輪廓，運中鋒筆。
Outline the rough shape of the fin.

天狗鯛

分佈於日本部太平洋沿岸，身長35公分。背鰭最為
寬大，臀鰭和尾鰭也各呈寬三角形，遠遠看去有如小
鳥在展翅飛翔。身上黑白相間的條紋十分搶眼，整個
色調與小黃蜂也很相似。尤為突出的，是牠一對藍眼
睛，宛如兩顆寶石般閃爍誘人的光芒。

Banded Boarchead (Evistias acutirostris)

They are common in the coasts of Japan.
They measure in length 35cm. All
the fins are wide and in triangular shapes.
When they swim in the water, the fins
waves gracefully as a bird flying in the
air.

②用羊毫筆蘸濃墨寫黑斑紋及腹鰭。
Draw the stripes and fin with dark ink.

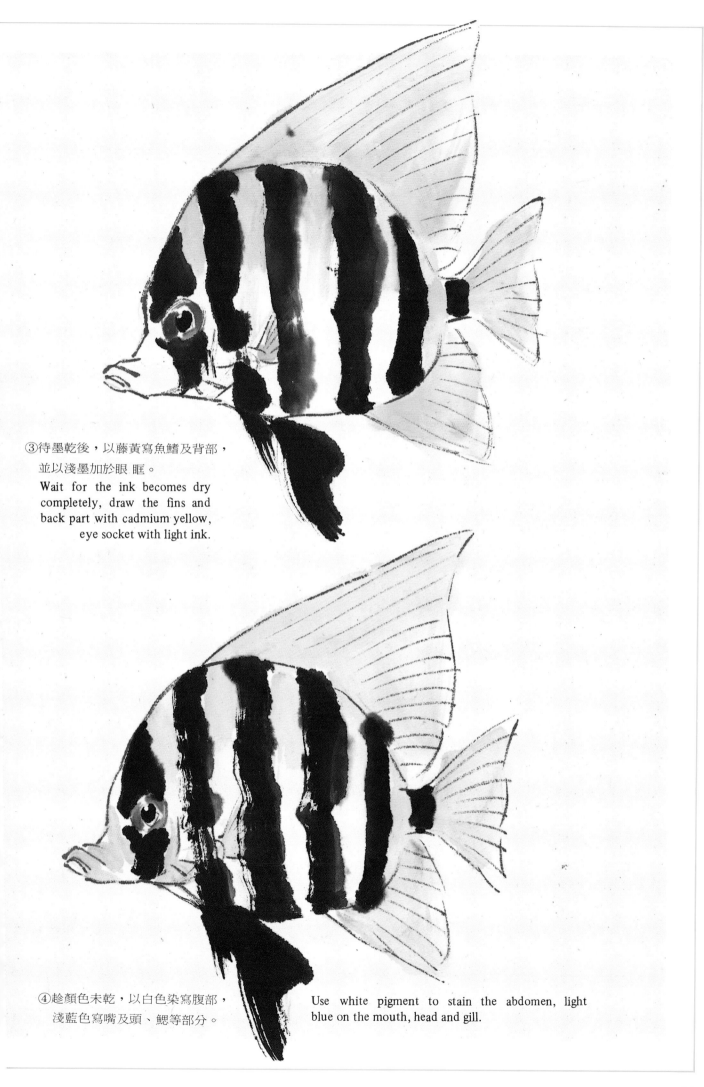

③待墨乾後，以藤黃寫魚鰭及背部，
　並以淺墨加於眼 眶。

Wait for the ink becomes dry
completely, draw the fins and
back part with cadmium yellow,
　eye socket with light ink.

④趁顏色未乾，以白色染寫腹部，
　淺藍色寫嘴及頭、鰓等部分。

Use white pigment to stain the abdomen, light
blue on the mouth, head and gill.

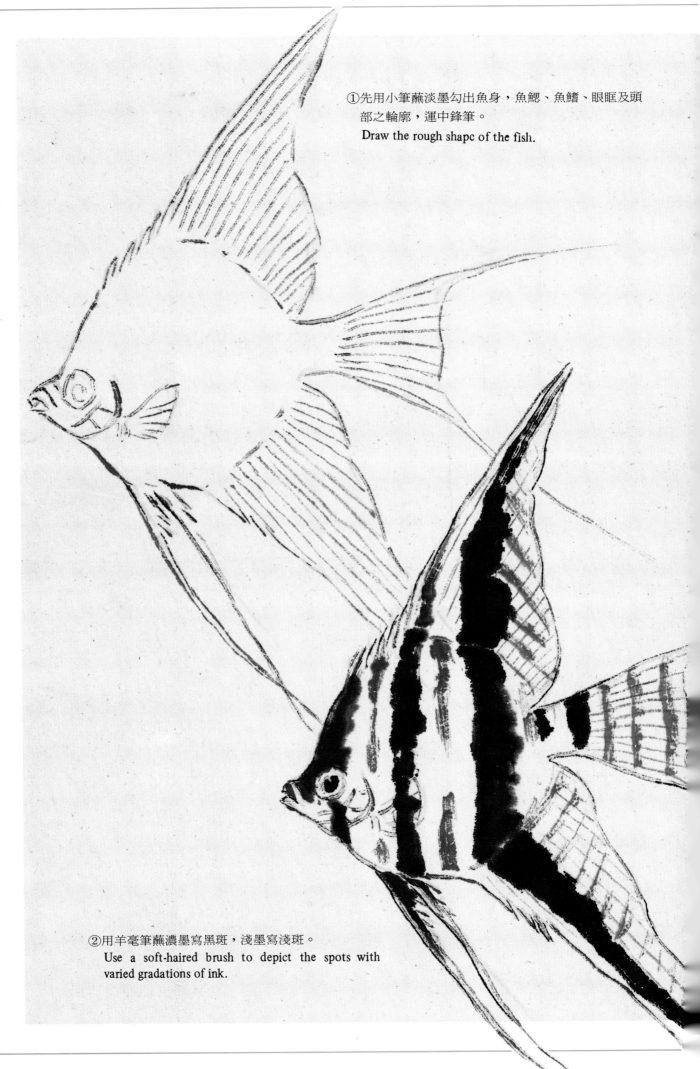

①先用小筆蘸淡墨勾出魚身，魚鰓、魚鰭、眼眶及頭
部之輪廓，運中鋒筆。
Draw the rough shapc of the fish.

②用羊毫筆蘸濃墨寫黑斑，淺墨寫淺斑。
Use a soft-haired brush to depict the spots with
varied gradations of ink.

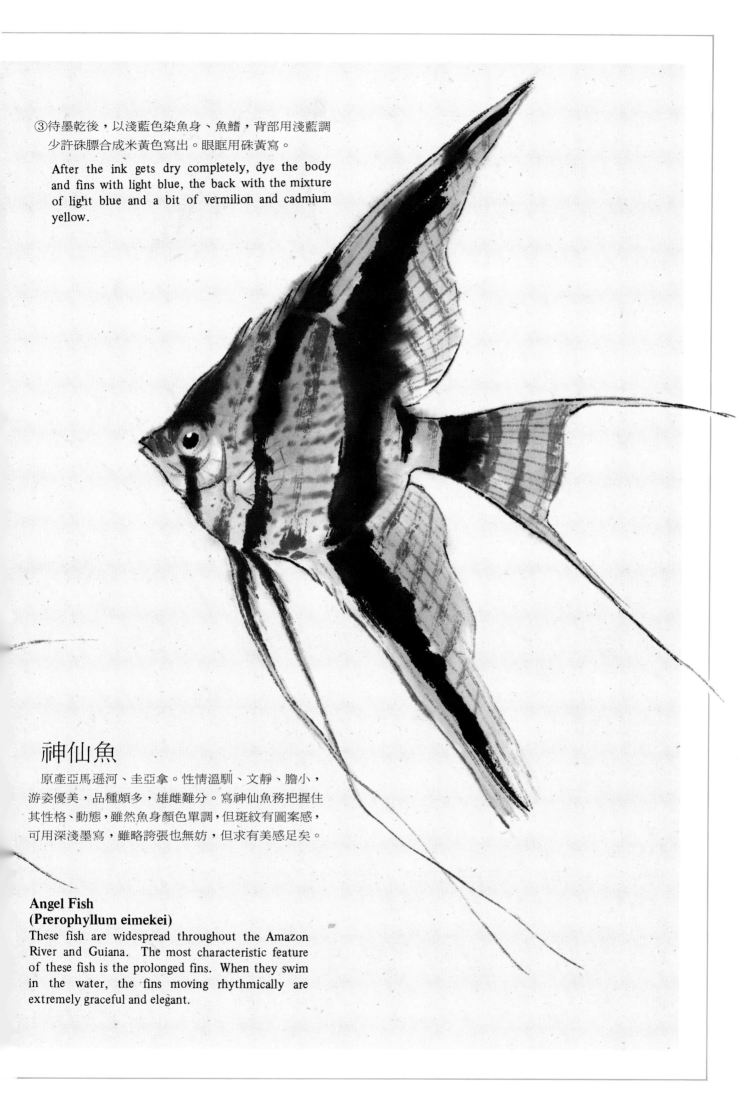

③待墨乾後，以淺藍色染魚身、魚鰭，背部用淺藍調
　少許硃膘合成米黃色寫出。眼眶用硃黃寫。

After the ink gets dry completely, dye the body
and fins with light blue, the back with the mixture
of light blue and a bit of vermilion and cadmium
yellow.

神仙魚

　原產亞馬遜河、圭亞拿。性情溫馴、文靜、膽小，
游姿優美，品種頗多，雄雌難分。寫神仙魚務把握住
其性格、動態，雖然魚身顏色單調，但斑紋有圖案感，
可用深淺墨寫，雖略誇張也無妨，但求有美感足矣。

Angel Fish
(Prerophyllum eimekei)
These fish are widespread throughout the Amazon
River and Guiana. The most characteristic feature
of these fish is the prolonged fins. When they swim
in the water, the fins moving rhythmically are
extremely graceful and elegant.

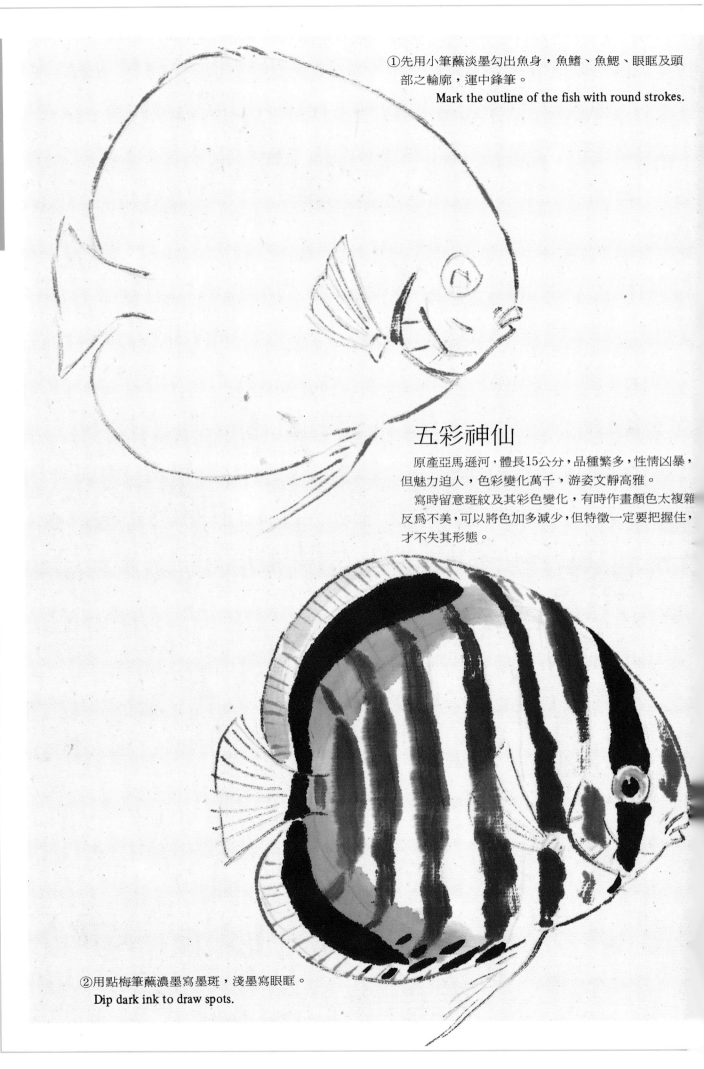

①先用小筆蘸淡墨勾出魚身，魚鰭、魚鰓、眼眶及頭部之輪廓，運中鋒筆。

Mark the outline of the fish with round strokes.

五彩神仙

原產亞馬遜河，體長15公分，品種繁多，性情凶暴，但魅力迫人，色彩變化萬千，游姿文靜高雅。

寫時留意斑紋及其彩色變化，有時作畫顏色太複雜反為不美，可以將色加多減少，但特徵一定要把握住，才不失其形態。

②用點梅筆蘸濃墨寫墨斑，淺墨寫眼眶。

Dip dark ink to draw spots.

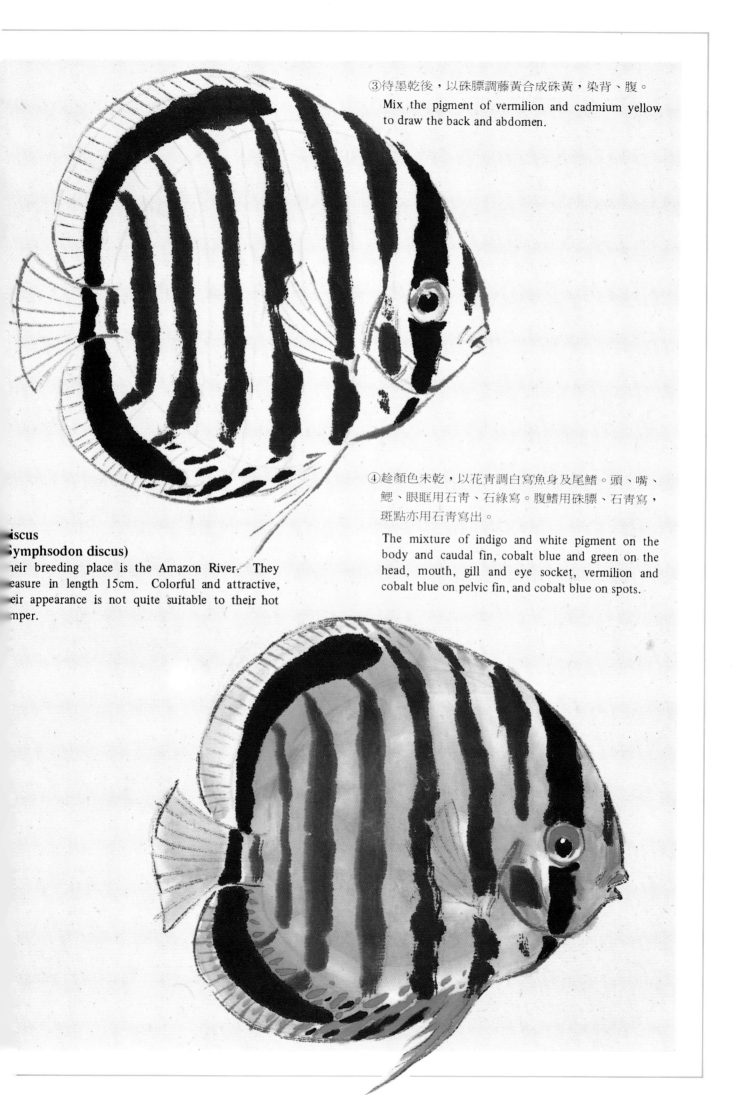

③待墨乾後，以硃膘調藤黃合成硃黃，染背、腹。

Mix the pigment of vermilion and cadmium yellow to draw the back and abdomen.

④趁顏色未乾，以花青調白寫魚身及尾鰭。頭、嘴、鰓、眼眶用石青、石綠寫。腹鰭用硃膘、石青寫，斑點亦用石青寫出。

The mixture of indigo and white pigment on the body and caudal fin, cobalt blue and green on the head, mouth, gill and eye socket, vermilion and cobalt blue on pelvic fin, and cobalt blue on spots.

iscus

ymphsodon discus)

heir breeding place is the Amazon River. They easure in length 15cm. Colorful and attractive, heir appearance is not quite suitable to their hot mper.

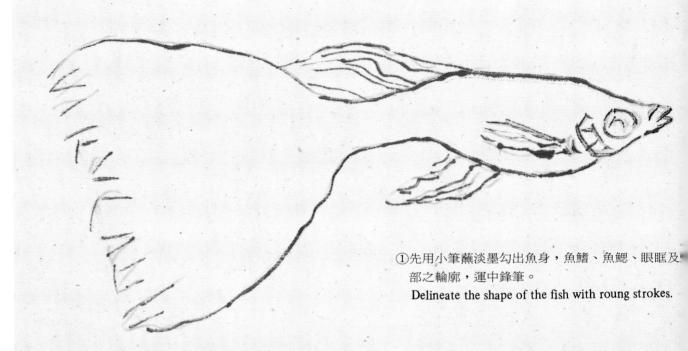

①先用小筆蘸淡墨勾出魚身，魚鰭、魚鰓、眼眶及

部之輪廓，運中鋒筆。

Delineate the shape of the fish with roung strokes.

孔雀魚

原產地為南美大陸、圭亞那，屬胎生魚。孔雀魚的尾鰭有各種形狀圖案顏色，富有變化而優美。性情溫馴，雄魚顏色鮮麗奪目，游態婀娜多姿，雌魚顏色則平凡不特出。

寫孔雀魚時須留意其尾部圖案，把握其要點。牠們游動時，很像少女穿上一件色彩繽紛的紗裙在舞台上輕柔妙舞，非常動人。

Guppy
(Poecilia reticulate)

They are located usually in south America and Guiana. The briliant colors and rhythmical designs are their main characteristics.

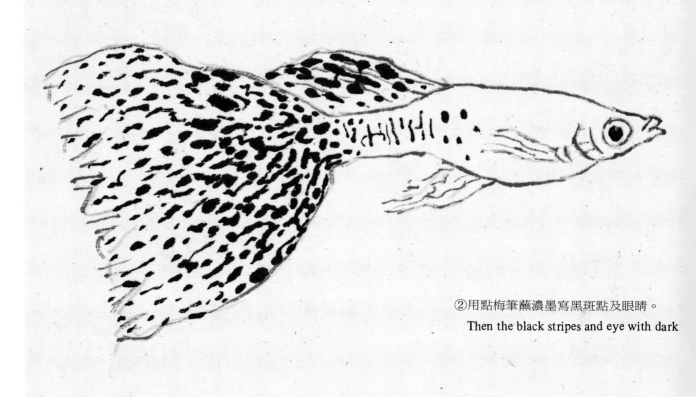

②用點梅筆蘸濃墨寫黑斑點及眼睛。

Then the black stripes and eye with dark

③待墨乾後，以硃膘寫紅斑及魚鰓。

Wait for the ink becomes dry totally, dip vermilion
to draw the stripes and gill.

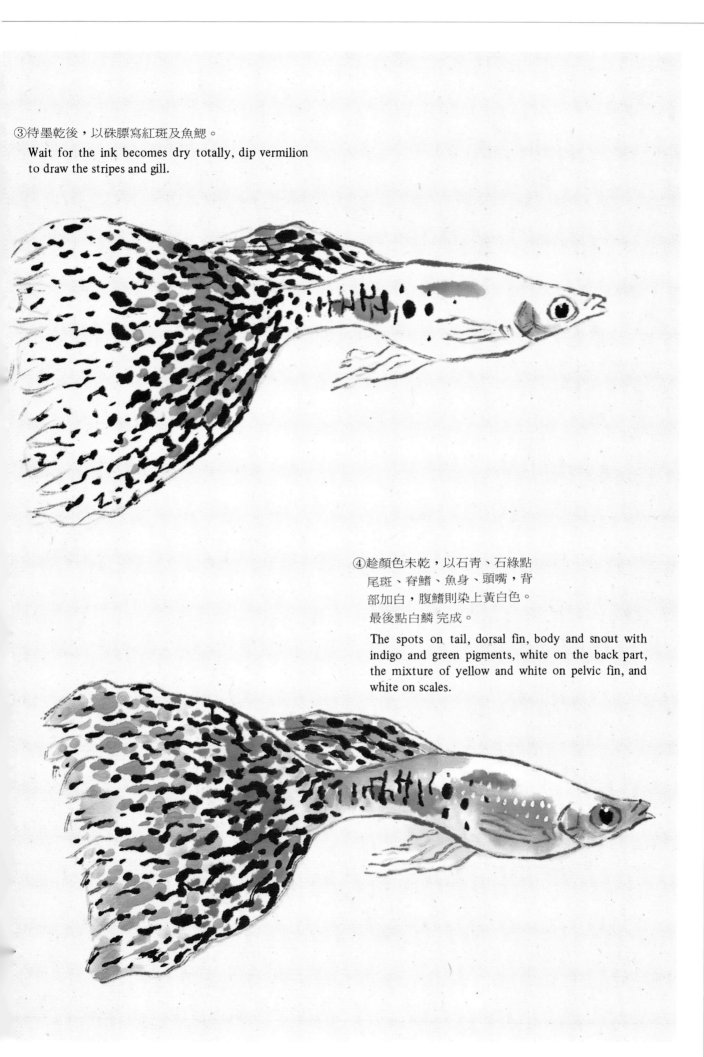

④趁顏色未乾，以石青、石綠點
尾斑、脊鰭、魚身、頭嘴，背
部加白，腹鰭則染上黃白色。
最後點白鱗 完成。

The spots on tail, dorsal fin, body and snout with
indigo and green pigments, white on the back part,
the mixture of yellow and white on pelvic fin, and
white on scales.

構圖法
（海水魚）

①四魚的分佈過於平均，看來散漫、平板，全無構圖可言。

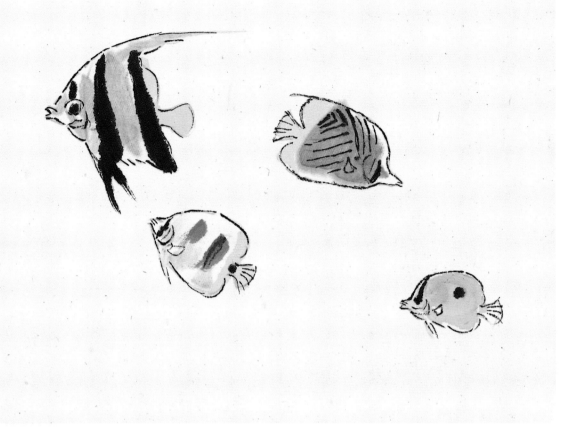

Arrangement of Composition

1. This is a bad arrangement because there is no link among the four fishes.

②四魚分別置於右上、左下方，把畫面截分為二，彼此缺乏呼應力，魚兒的神緒和感情也不能表達出來。

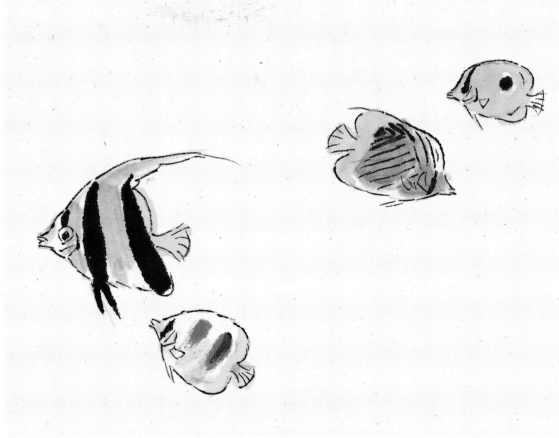

2. Two on the upper right, and the other two on the below left try to divide the picture into two parts. The lack of link is also the defect of the picture.

③四魚在畫面正
中聚成一團，顯
得迫促而呆板，
也缺乏圖案美。

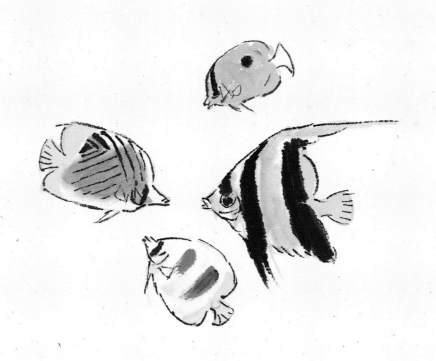

3. The distribution of arranging four objects in a
 concentric ring adds to a sense of stiffness.

④畫面佈局聚散
得宜，具構圖之
美。魚兒彼此間
有呼應，亦能表
達出水中暢泳，
來去自如的優閒
神態。再配上海
草，更能襯托出
自 然 生 動 之 氣
息。

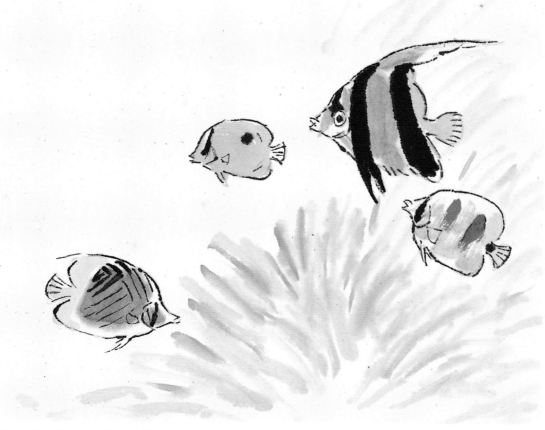

4. The disposition of positions, moving directions,
 and density lead to a fascinating structure.

構圖法
（五彩神仙魚）

①三魚排列成一
三角形，構圖
呆板，缺乏美
感。畫面組織
亦不夠緊湊。

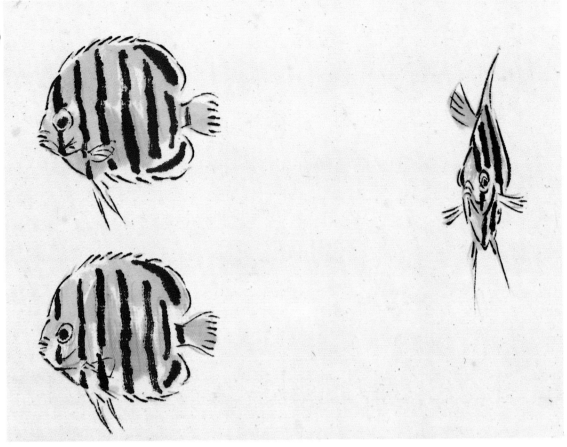

Arrangement of Composition
1. The three fish are shaped into a triangular structure,
geometric and stiff.

②三魚排成一直
線，不夠自
然，顯得乏味
平板。

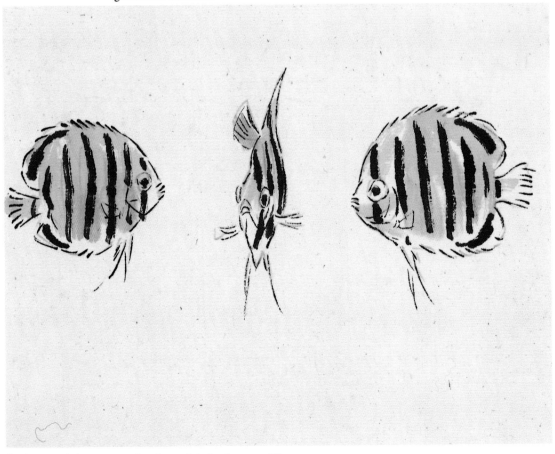

2. Arranged in a row, the three fish look more like a
design rather than a picture.

③三魚之間的距
　離太平均，使
　畫面鬆散，缺
　乏張力。

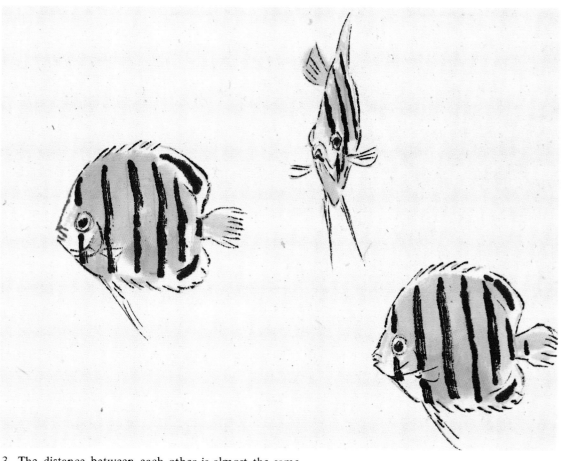

3. The distance between each other is almost the same
 which makes the structure dull and inflexible.

④各魚動態彼此
　不一，神態自
　然生動，穿梭
　於輕柔水草之
　間，表露出一
　份悠閒自得之
　態。

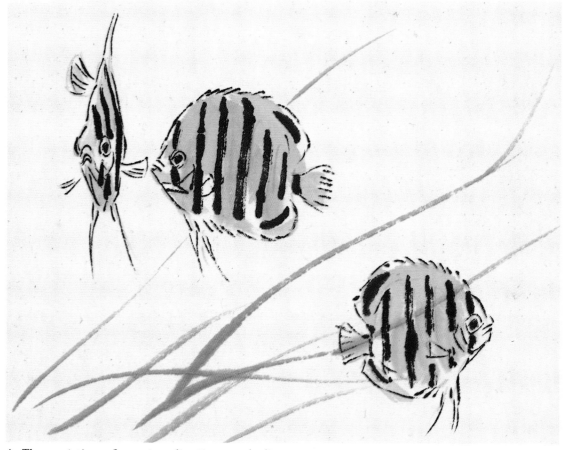

4. The varieties of moving directions and distance
 between each other lead to a vivid and natural
 composition.

構圖法
（神仙魚）

①兩魚正面相遇，過於對稱，以至流於呆板，沒有構圖美。

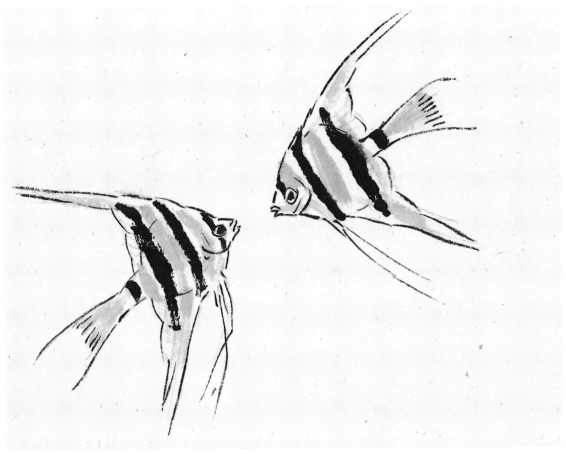

Arrangement of Composition
1. These two fish facing each other look like a pattern design.

②兩魚重疊過多，缺乏聚散和呼應力，故沒有立體感。

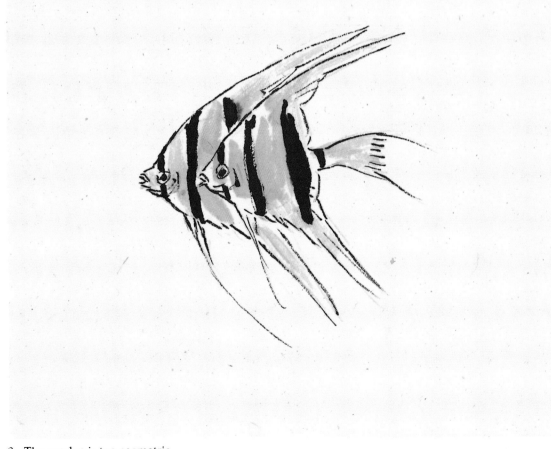

2. The overlap is too geometric.

③兩魚前後排成
一直線，佈局過
於整齊，缺乏構
圖美，亦失諸自
然。

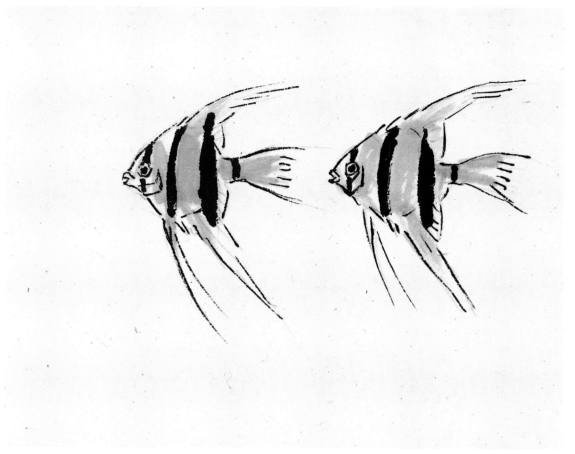

3. Arranged in a row, they look like two soldiers, stiff and dull.

④兩魚位置自
然，互為呼應，
情致洋溢。有和
影共依依之態，
在水草的掩映
下，更覺生動顯
逸。

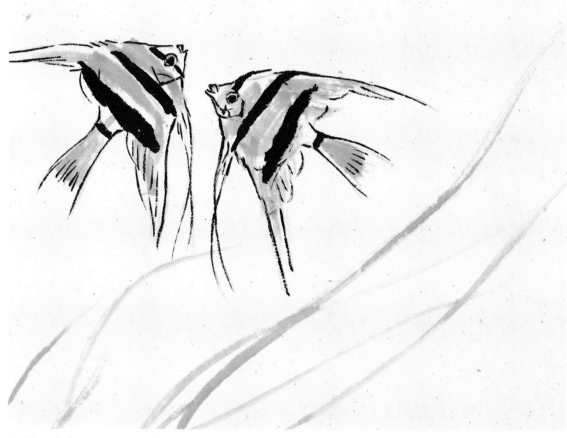

4. The slight variety makes the composition more vivacious and animated.

Steps Guiding (2): Arrangment of Composition

基本技法(二)：基本構圖

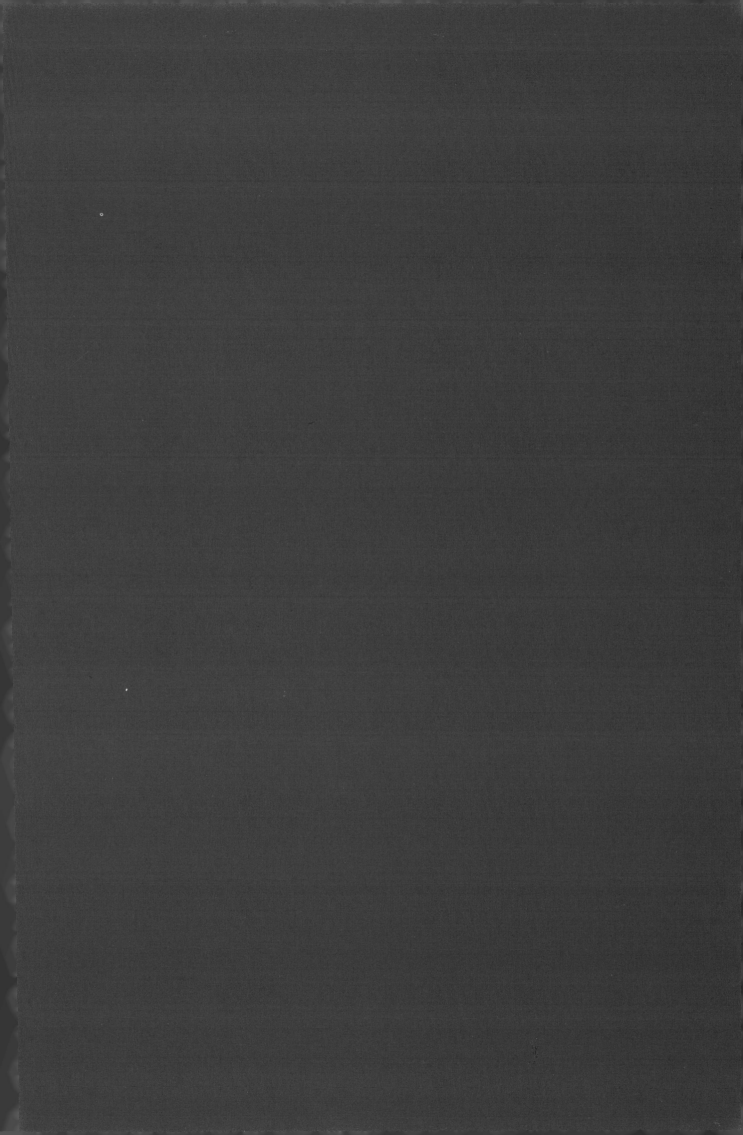

八帶蝶魚

Chaetodon punctatofasciatus

橙紅的體色配上八條像斑馬般的條紋是其特徵。常見活動於珊瑚深海。

①構圖時先以中鋒筆鈎出輪廓，再寫斑紋。

②用硃灰着魚身，近腹，鰓，嘴處，着少許白色。脊鰭、尾、眼眶着淡墨綠色。

③以毛氈墊底，先寫草，後染水。水草色宜淡雅。此圖畫面空間多，寫長水草需加強畫面組織之連貫，用輕快筆調，彷彿草在動、魚在游行。

④題字蓋章完成。

The brilliant orange body decorated with eight stripes swims carefreely around coral reefs.

(1) Outline the shapes of these fish, then the stripes with

(2) Dip vermilion to wash the body, soak a bit of white pigment for the abdomen, gill and snout. Dilute dark green for the fin, tail and eye socket.

(3) Put a piece of cloth under the picture paper, depict the grass, then the water. Notice the relationship of fish and grass to make the depiction more animated.

(4) Put the inscription and seal on.

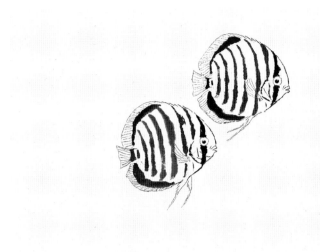

①

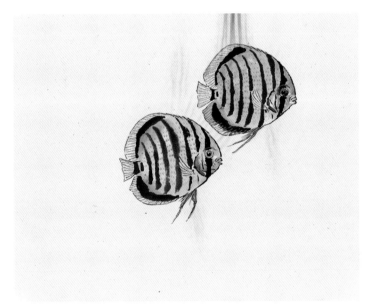

②

③

④

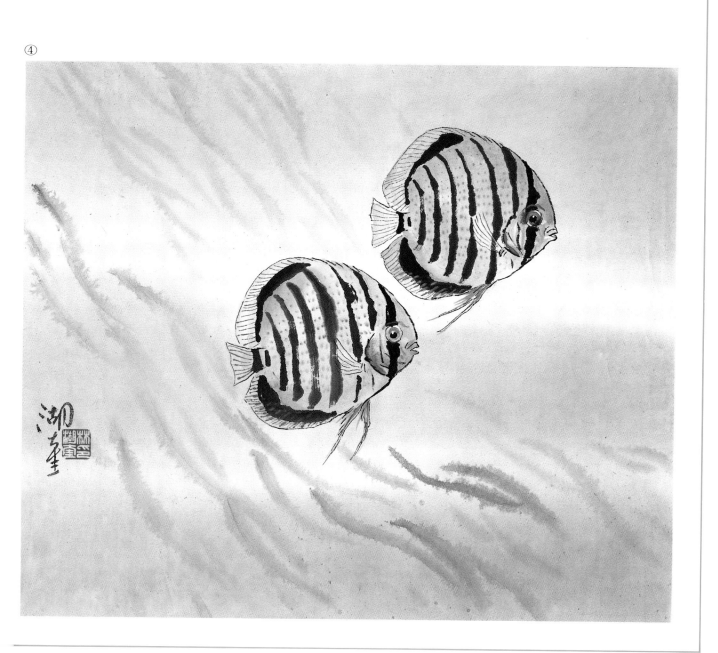

一點蝶魚
Chaetodon unimaculatus

魚身後背部，有個白色鑲邊的黑點。身上並有葉紋，眼睛上下方分佈著大小不一的黑帶，喜歡在珊瑚礁面嬉遊。

①構圖時先以中鋒筆鈎出輪廓，再寫墨斑紋。
②用赭石着魚身、腹。鰓着白色。脊、尾着淡石靑。
③以毛氈墊底，再噴濕畫面，然後以淡咖啡色寫草。白底爲水，寫草宜淡雅，才能襯托出主體。
　寫草時須表現出其生命力，畫出其隨水左搖右擺之姿態，才顯生動。
④題字蓋章完成。

The very characteristic of these fish lies in a black dot bordered with white coloration in the back. There are the special leave-shaped stripes on the body, as well as the dark bands around the eyes.

(1) Delineate the shapes of the bodies, the stripes with straight strokes.
(2) Cadmium red for the body, white pigment for the gill and light cobalt blue for the back and tail.
(3) Cushion a piece of cloth under the paper, slightly spray the picture, then dip light brown for the grass. Notice the depiction of grass should be simple and clear to make the theme more conspicuous.
(4) Put the inscription and seal on.

①

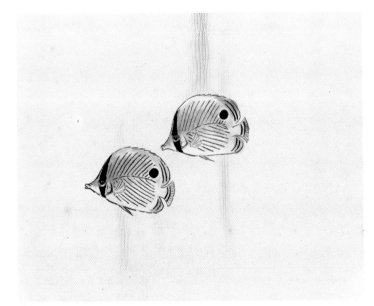

②

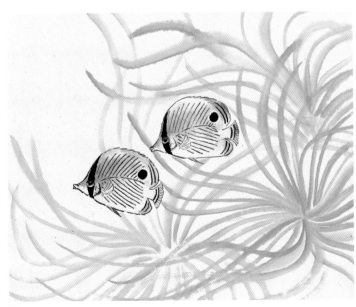

③

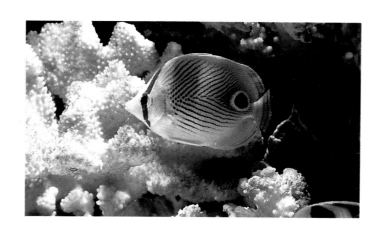

④

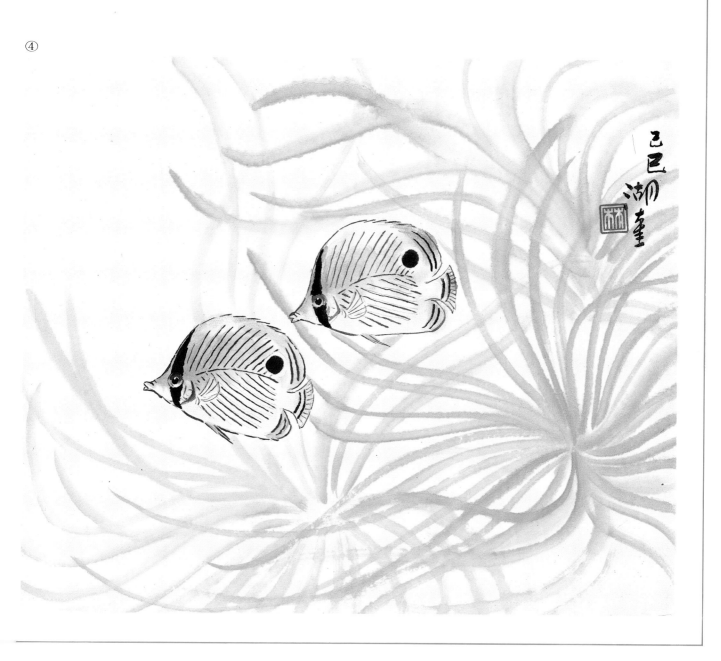

孔雀魚

Cuppy

孔雀魚的尾巴張開時如色彩繽紛的扇子，由於
經過配種的關係，目前各種五花八門的色彩都
可找到，屬熱帶魚。

①孔雀魚體形細小，在構圖時可多寫幾尾，使
　之前後左右互相穿梭。有組織，呼應自然的
　魚群，頗像少女穿着彩裙在台上輕柔曼舞。

②孔雀魚顏色多彩奪目。但畫時，不宜用太強
　烈的色彩，以和諧淡雅之色為佳。

③用毛氈墊底，噴濕畫面，先寫草，後染水，
　水草宜淡雅，才能托出主體。

④題字蓋章完成。

Cuppy's tail, which looks like a magnificently colorful
fan, would appear especially beautiful in the period of
seeking a spouse.

(1) Owing to the tiny and slender body, the depiction of
 Cuppies usually is in groups, which will make the
 whole composition more complete and organized.
(2) Although these fish own very colorful bodies, the
 depiction is not suitable to the application of strong
 pigments but mild and harmonious ones.
(3) Cushion a piece of cloth, spray the picture, then depict
 the grass and ocean.
(4) Put the inscription and seal on.

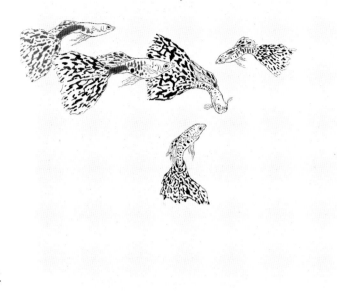

①

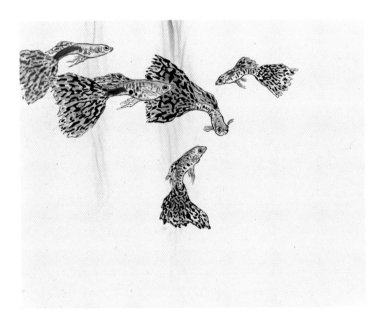

②

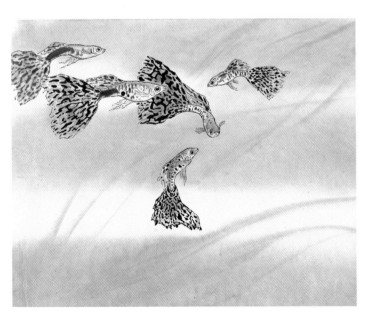

③

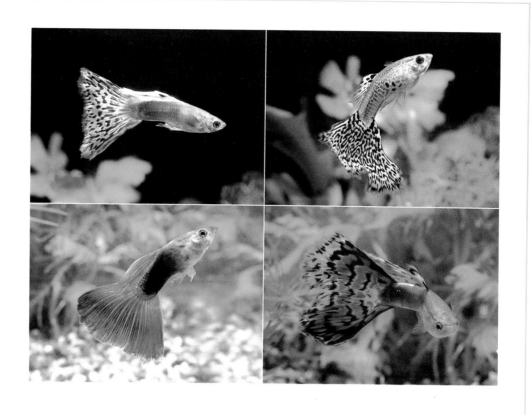

④

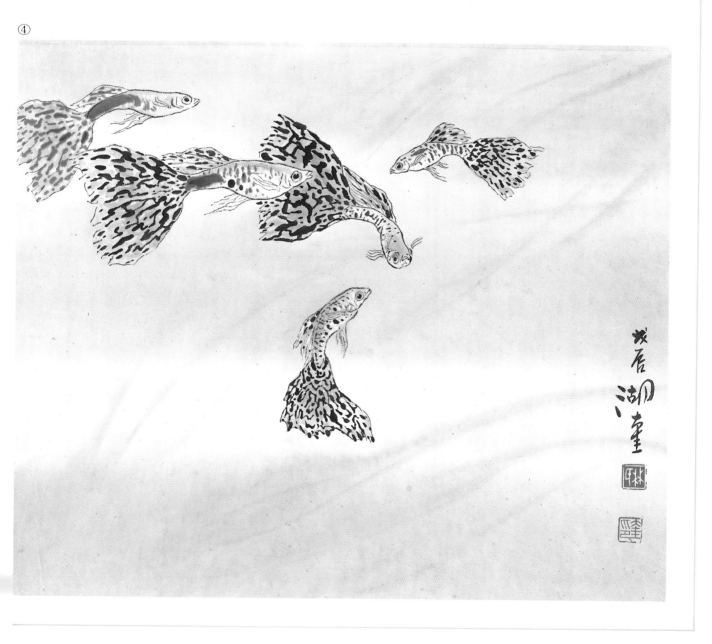

神仙魚

Angel Fish

神仙魚之美，美在牠有如彩帶飛舞的葉鰭，尤
其在曼妙水草的配合下，更顯婀娜而多姿。

①以神仙魚之聚散爲構圖，有呼應、神態各異，
　畫面才顯生動。以中鋒筆鈎出輪廓，後寫墨
　斑，用筆以表現魚兒之輕盈靈活爲佳。

②用墨綠色着上半身，下半身用白色。眼眶加
　少許硃黃。

③以毛氈墊底後噴濕畫面，先寫草，後染水。
　草用墨綠色，水用花青調少許墨染。留少些
　水光位才會顯得美觀。

④題字蓋章完成。

The thrilling beauty of Angel fish lies in their resplendent
and colorful fins, which gracefully undulate in the sea.

(1) Depict the outlines of these fish with round strokes.
(2) Dark green for the upper body and white pigment for
the other part. Dip a bit of the mixed pigments of ver-
milion and yellow for the eye socket.
(3) Cushion the paper and spray the picture. Draw the
grass and sea water.
(4) Put the inscription and seal on.

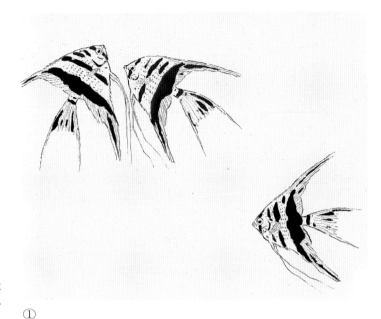

①

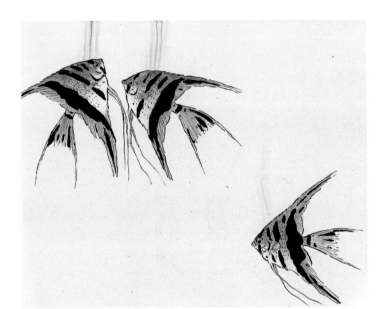

②

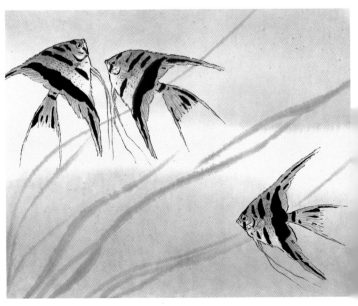

③

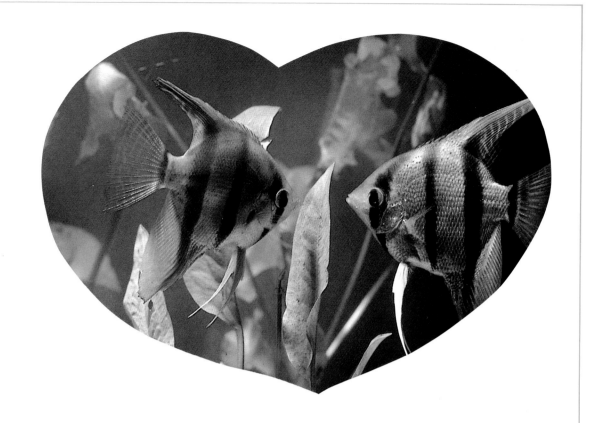

④

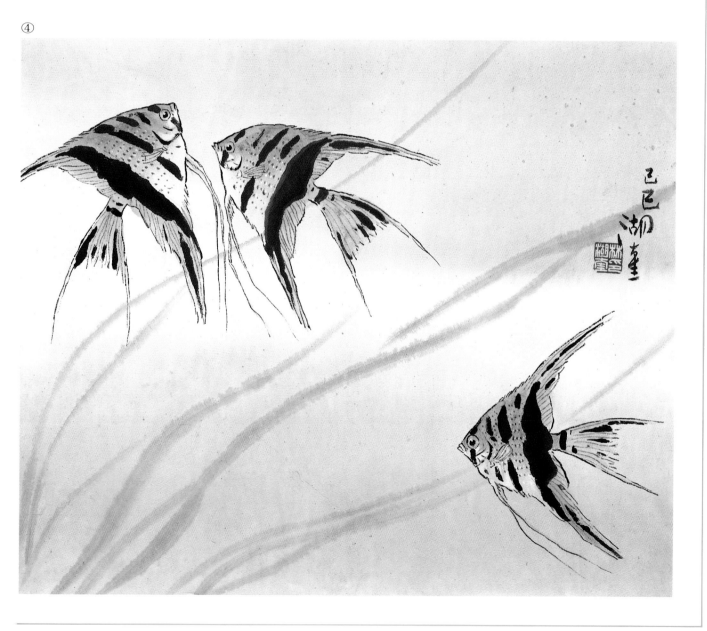

細鰭蝶魚

Chaetodon auriga

這種蝶魚，鰭小嘴也小，經常靜止不動地在水
中停留，因此背景不必複雜，空白也可以。

①先構圖。以中鋒筆鈎出輪廓，再寫墨斑紋。

②着色要淡雅而有透明感，不可過份鮮明刺
　眼，以樸素古雅爲佳。

③以毛氈墊底後噴濕畫面。先用硃腺調赭石染
　海底，次染石綠。海底顏色不宜太複雜，宜
　用朦朧淡彩，才能托出主體。

④題字蓋章完成。

Owing to the stillness typical of these fish, the background
should be simple in accordance with the representation
of quiet atmosphere.

(1) Delineate the shapes of these fish and the stripes.
(2) The application of colors should be mild and
 transparent rather than strong and brilliantly sharps.
(3) Cushion the paper and spray the picture. Dip the mix-
 ed pigments of vermilion and cadmium red, to draw
 the sea water, then stain a layer of green pigment.
(4) Put the inscription and seal on.

①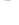

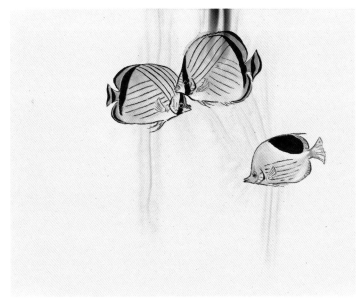

②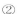

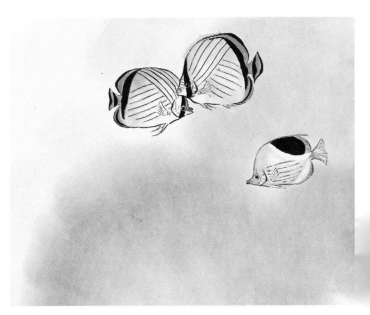

③

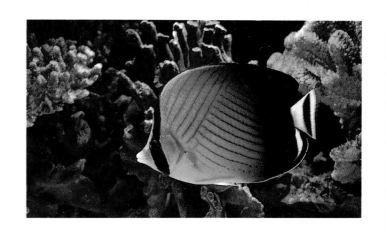

④

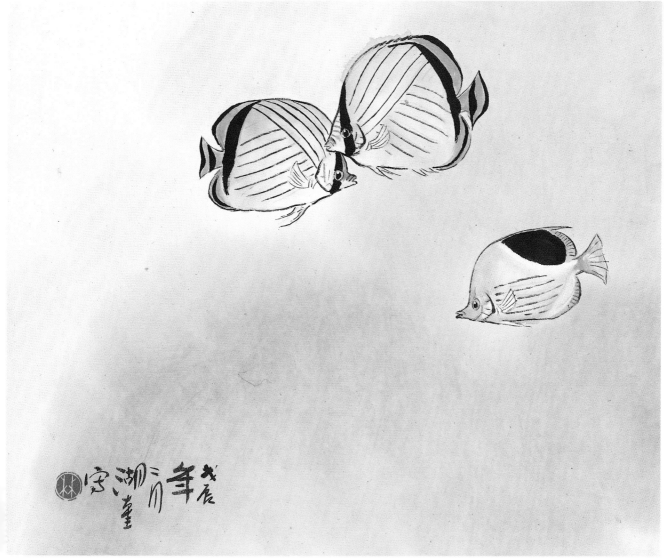

魏氏蝶魚

Chaetodon Wiebeli

魏氏蝶魚腹部有二塊黑色斑，身上常有三條白
紋，經常在深海中像夢般的游行，是入畫的好
題材。

①先構圖。以中鋒筆鈎出輪廓，再寫墨斑紋。

②先着黃色，後着白色。頭部着少許墨綠色。

③以毛氈墊底。先寫海珊瑚，色須有深淺，但
　不可太複雜，以和諧爲佳。乾後噴濕，染水
　色，留水光，畫面方有朦朧感。

④題字蓋章完成。

These fish is characterized by two lump of black spots
and three white stripes. ˋ

(1) Shape the rough structure.
(2) Apply yellow, then white pigment to the bodies. Dip
　　a bit of dark green for the head.
(3) Cushion the paper and draw coral reefs, which should
　　be shown the gradations of tonality. After the
　　pigments become dry completely, spray the picture and
　　depict the sea water.
(4) Put the inscription and seal on.

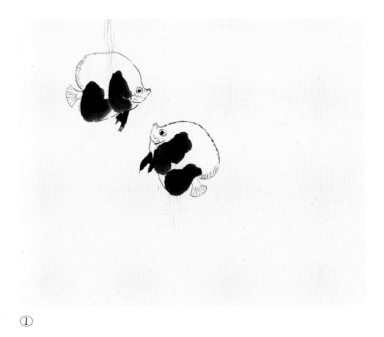

①

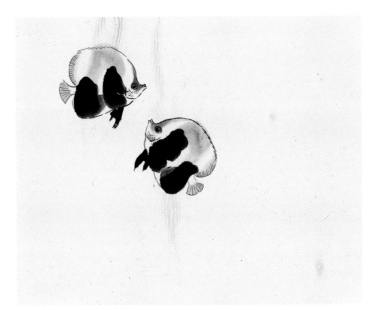

②

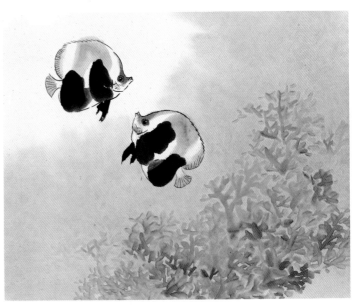

③

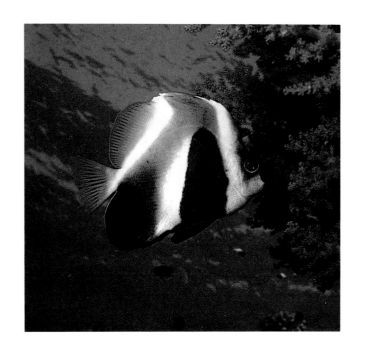

④

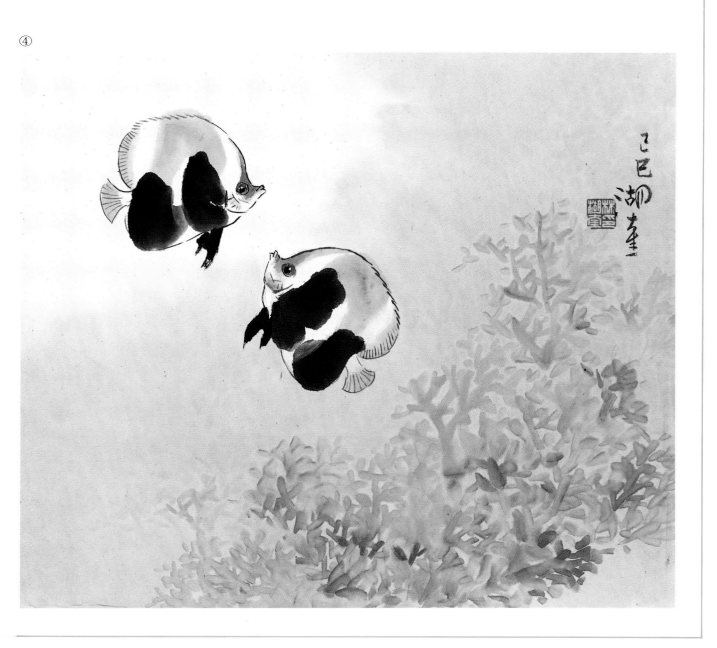

天狗鯛

Evitias acutirostris

這種雀鯛魚,如五帶蝶魚,身上有五條黑斑紋,
但魚鰭較大,不像蝶魚的薄小。生活在珊瑚礁
中。

①先構圖。以中鋒筆鈎出輪廓,再寫墨斑紋。

②天狗鯛,本身有五條黑斑紋,富圖案感。能
　把握其特徵,再加上淡雅色調,便覺黑白分
　明。

③以毛氈墊底。先寫珊瑚樹,後染水色。寫珊
　瑚樹時用色不可太複雜,宜用單調淡雅色,
　才能襯出雙魚。

④題字蓋章完成。

The five black stripes and big fins are characteristics of
these fish.

(1) Shape the outlines of these fish, then their stripes.
(2) These fish are characterized by five black stripes.
(3) Cushion the paper and draw corals first, then stain
　　the sea water.
(4) Put the inscription and seal on.

①

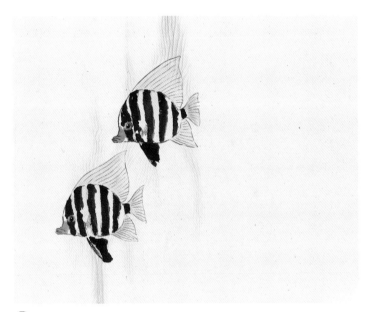

②

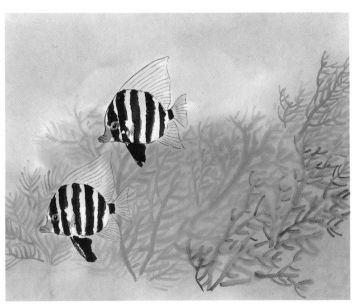

③

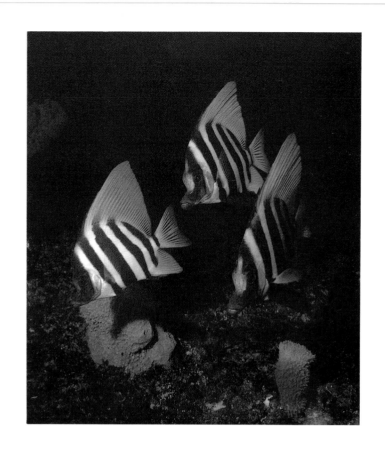

④

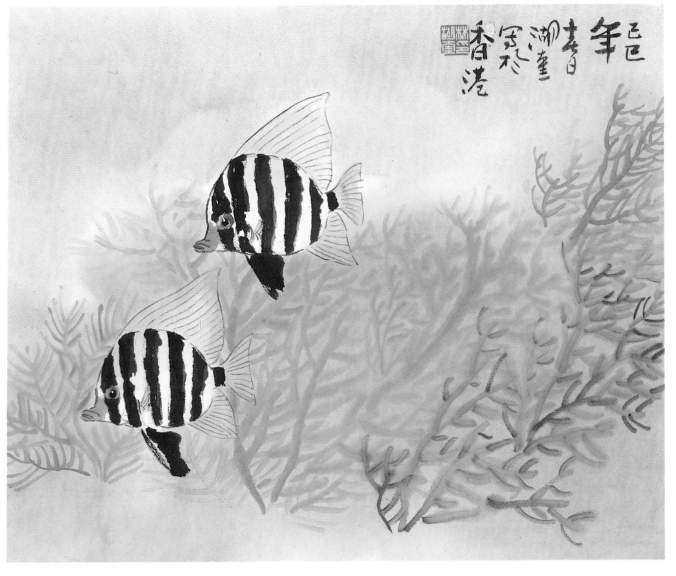

己
巳
年
春
青
湖
寫
於
邑
寓
香
港

三趾蝶魚

Chaetodon Oxycephalus

三趾蝶魚眼帶，跟眼睛上方相連接，額頭上有分離的三角形黑斑。魚鰭張開時如鋸齒狀，牠也在珊瑚帶邊活動。

①先構圖。以中鋒筆鈎出輪廓，再寫黑斑、點魚鱗。

②三趾碟魚本身有雙間墨斑，像個八字，呈強烈對比。以淡雅色調着魚身，便顯明朗動人。

③以毛氈墊底後噴濕畫面，再用深淺紫色寫海草，用筆要輕盈靈活，使人感覺到草在水內搖搖擺擺，畫面才顯生動。

④題字蓋章完成。

These fish is characterized by the triangular black spots on the head and saw-toothed fins.

(1) Delineate the outlines of these fish, then the black dots and scales.
(2) Put emphasis on the depiction of black dots to make the whole surface more attractive.
(3) Cushion the paper and spray the picture. Draw the sea grass with purple pigments.
(4) Put the inscription and seal on.

①

②

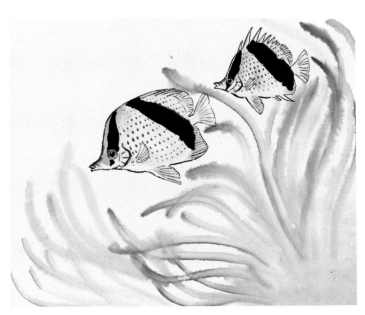

③

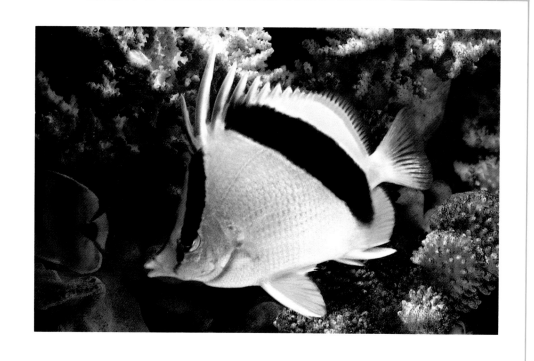

④

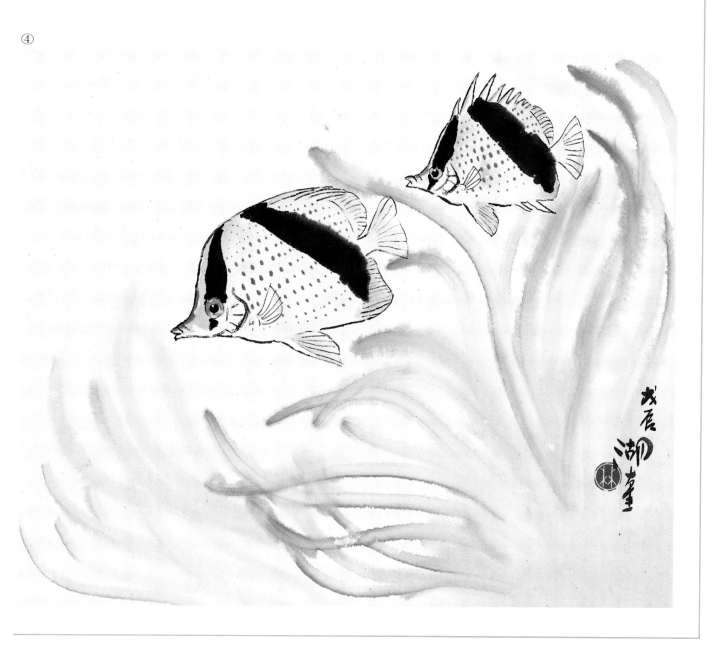

巛 紋蝶魚

Chaetodon trifascialis

這種蝶魚身上有好幾條石青色迴紋，魚鰭像彩蝶的翅膀，嘴小而細長，喜歡躲在珊瑚礁中，很膽小怕驚。

①先構圖。以中鋒筆鉤出輪廓，再寫墨斑。

②用石青着魚身，腹部着白色，背及尾着黃色。趁水未乾再寫藍紋。用色時層次須分明。

③以毛氈墊底後噴濕畫面，再用羊毫筆寫出兩種海草之顏色。以白底爲水。此圖因雙魚體積小，空間多，故多寫海草以補其空間，豐富畫面。草色以淡彩爲佳，才能突顯出雙魚之主題。

④題字蓋章完成。

The continuous X-shaped stripes, the black dots on the fins, and the orange coloration around the body are their characteristics.

(1) Draw the outlines of these fish.
(2) These fish are characterized by the black lines on the eyes, black dots on the back and the half hidden horizontal lines on the body. Their appearance is brilliantly colorful and patternized.
(3) Cushion the paper and spray the picture. Use white pigment to depict the sea water, then draw the undulating grass.
(4) Put the inscription and seal on.
round strokes.

①

②

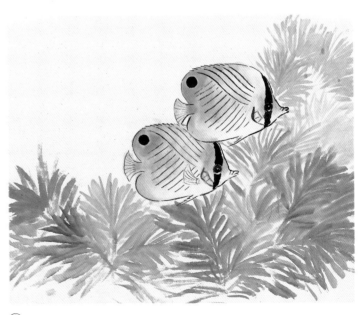

③

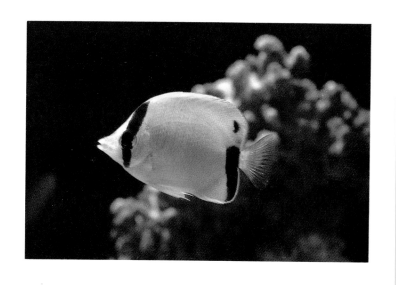

④

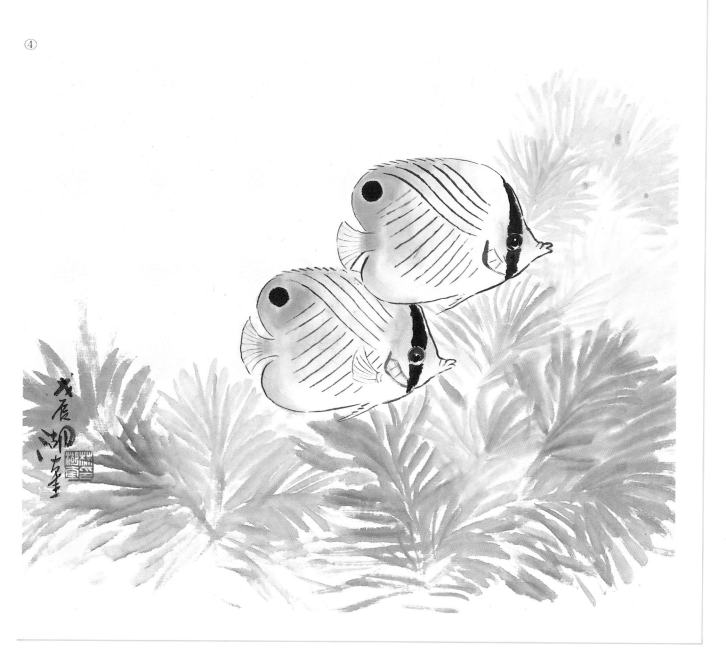

鞍斑蝶魚

Chelmon rostratus

三種不同的蝶魚,同在一直線的構圖,經常不
好處理,唯有把一條魚的頭部姿勢朝上,才能
產生變化,而不失呆板。

①先構圖。以中鋒筆鈎出輪廓,再寫墨斑紋。

②將每條魚着色,用色要淡雅,具透明感,並
　且深淺分明。

③以毛氈墊底後噴濕畫面,再用排筆染出三種
　色,用色宜淡雅,留水光。海水以具朦朧感
　爲佳。

④題字蓋章完成。

These fish are remarkably noted for the habit of attaching
to the other kinds of fish.

(1) Delineate the outlines of these fish, dots and scales
 with round strokes.
(2) The unique characteristic of these fish lies in the
 double black bands and the extremely long dorsal fin.
 The upper body is usually rendered with creamy
 yellow, the lower part with silver, and caudal fin with
 yellow pigment.
(3) Cushion the paper and spray the picture. Draw the
 sea water and depict several corals.
(4) Put the inscription and seal on.

①

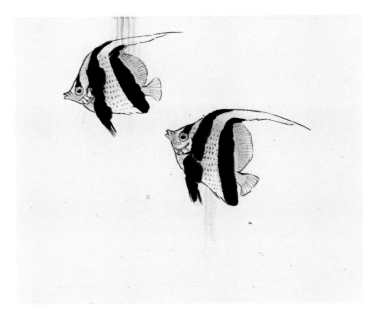

②

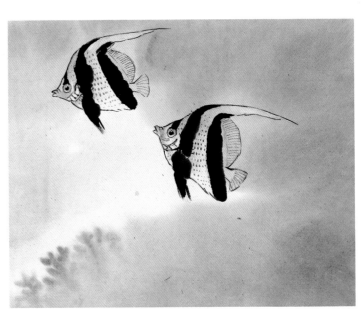

③

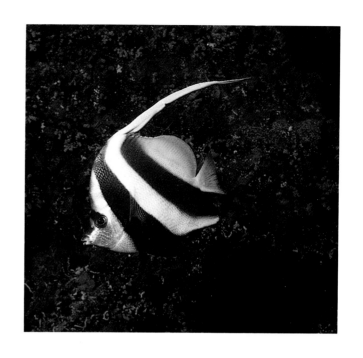

④

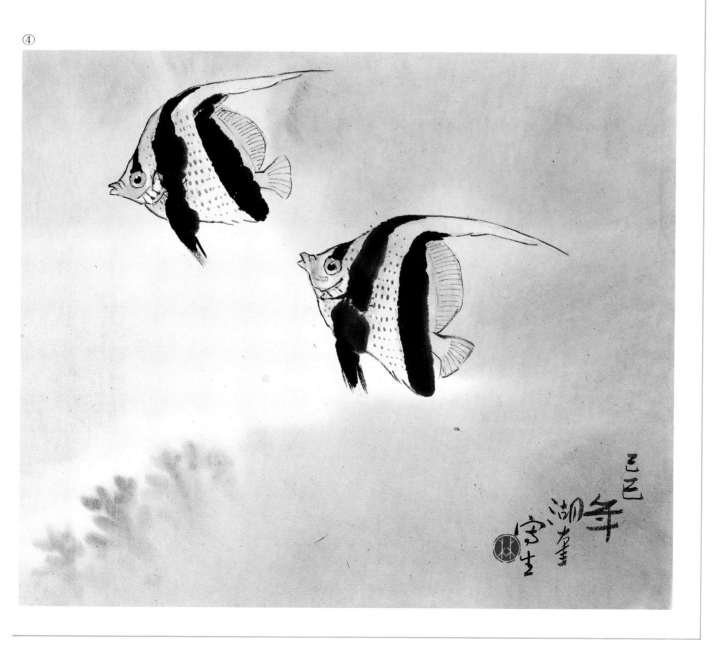

楊蟠蝶魚

Chaetodon adiergastos

楊蟠蝶魚身上有交叉斜紋，後方魚鰭有個黑點，四週全是柑紅色。牠們對對悠游，似彩蝶般飛舞。

①先構圖。以中鋒筆鉤出輪廓，再寫黑斑。

②楊蟠碟魚，以眼睛的黑綫及背上黑點爲特徵，身暗藏淡橫紋，別具一格，非常具有圖案美，前身着藍白色，後身着黃色，顏色要層次分明，方有透明感。

③用毛氈墊底，噴濕畫面。以白底爲水，再用羊毫筆寫出柔軟海草，彷彿草在水內搖動，以加強魚的動感。

④題字蓋章完成。

The structure should be noticed when three fish are arranged in the same pictorial surface.

(1) Draw the outlines of these fish, then the stripes.
(2) In application of colors, the sense of transparency and gradations of tonality should be noted.
(3) Cushion the paper and spray the picture. Draw the sea water with light and mild pigments.
(4) Put the inscription and seal on.

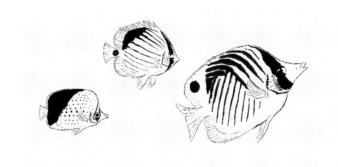

①

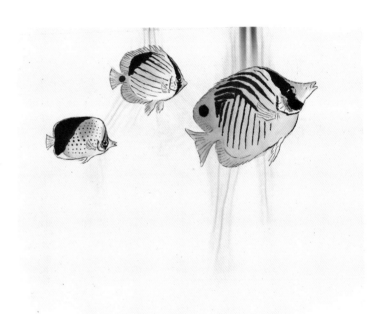

②

③

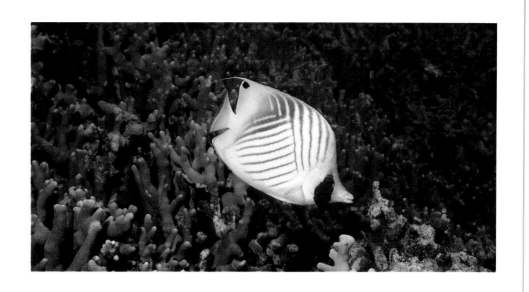

④

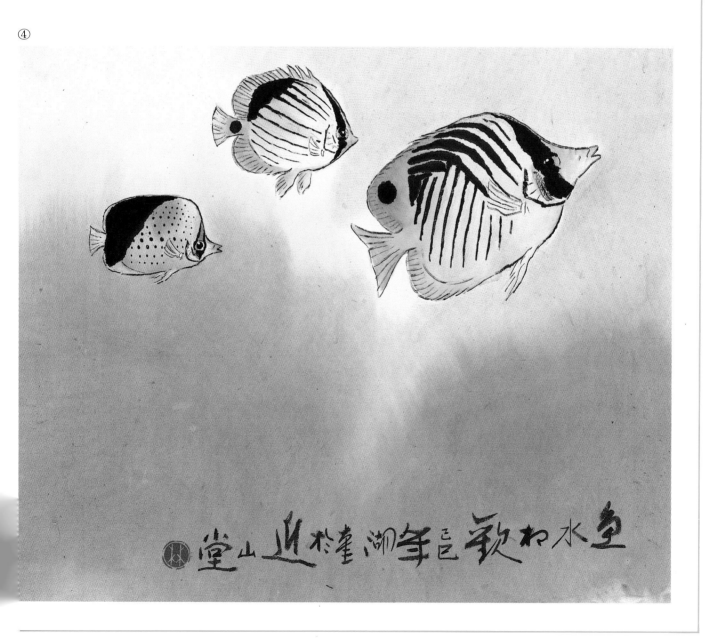

立旗鯛

Heniochus acuminatus

養過海水魚的人都知道，立旗鯛的習性是喜歡緊貼著他魚游行，似乎在為對方清除寄生蟲。鰭背上有一細三角形，有如一面旗幟招展。

①先構圖。以中鋒筆鈎出輪廓，再寫黑斑、點鱗。

②立旗鯛，其最大特點是身有雙黑帶，背鰭特別長。寫時能把握特徵，才能使畫面看來生動。上身著米黃色，下身著銀白色，尾鰭則著黃色。

③以毛氈墊底後噴濕畫面，再用排筆染海底。留水光。趁水未乾再加寫少許珊瑚樹，以呈現朦朧美為佳。

④題字蓋章完成。

The black stripes together with the brilliantly colorful body lead to a wonderful picture.

(1) Outline the shapes of these fish, then their stripes.

(2) For the complexly colorful appearance of the Angel fish, it is wise to depict comparatively uncomplex fish.

(3) Cushion the paper and spray the picture. Use a soft-haired brush to depict grass, then dip the mixed pigments of indigo, and a bit of ink and green to wash the grass.

(4) Put the inscription and seal on.

①

②

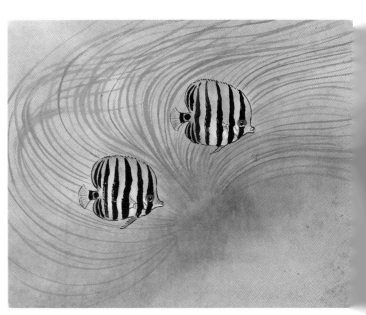

③

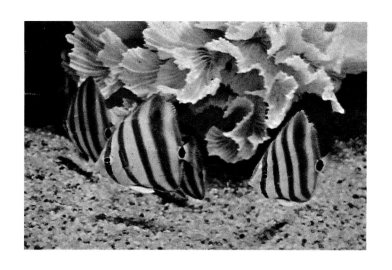

④

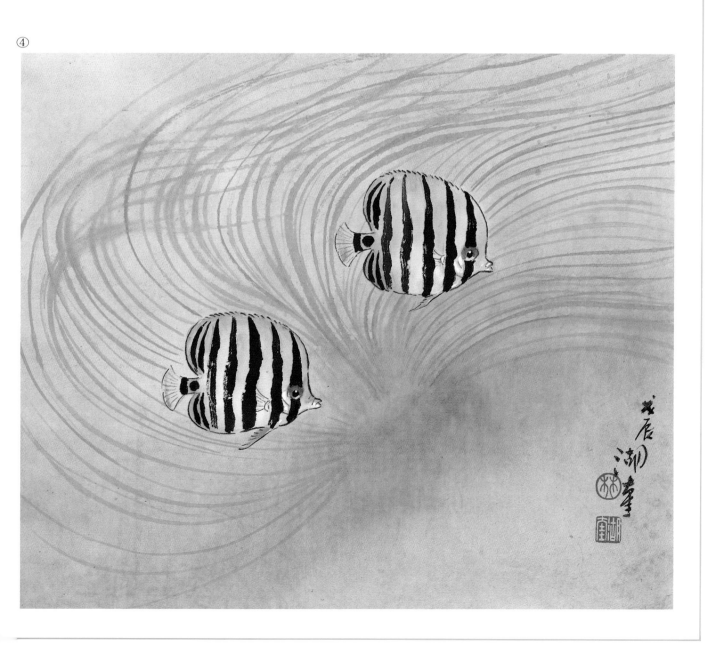

飄浮蝶魚
Chaetodon Vagabundus

三種蝶魚在一起，必須把最動人，變化最多的安排在前方。在最前方的飄浮蝶魚，魚體呈白色，四周柑紅色，魚斑都呈黑色。

①先構圖。以中鋒筆鈎輪廓，再寫黑斑紋。

②將每條魚着色，色須具透明感，並且深淺分明。

③以毛氈墊底後噴濕畫面，再用排筆染海底，留水光。用色不可太鮮明、複雜，以染出雅淡朦朧之感爲佳。

④題字蓋章完成。

These fish are so timid and easily frightened that they are fond of hiding among coral reefs.

(1) Shape the outlines of these fish.
(2) Cobalt blue for the body, white pigment for the abdomen and yellow for the back and tail. Draw the blue stripes when the pigments are still wet.
(3) Cushion the paper and spray the picture. Use a soft-haired brush to depict sea grass.
(4) Put the inscription and seal on.

①

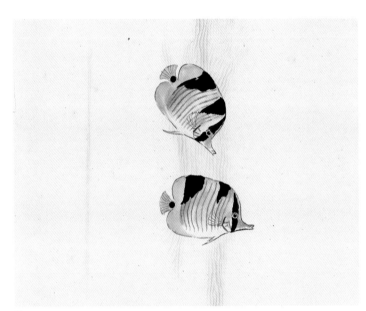

②

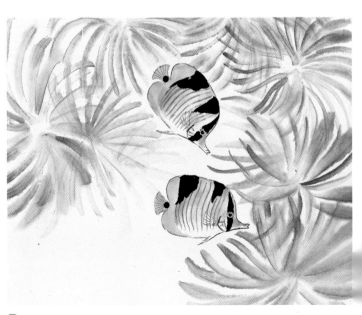

③

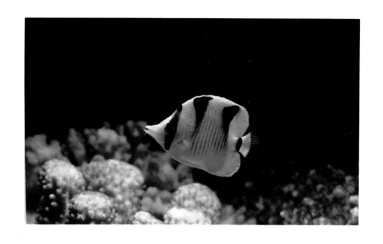

④

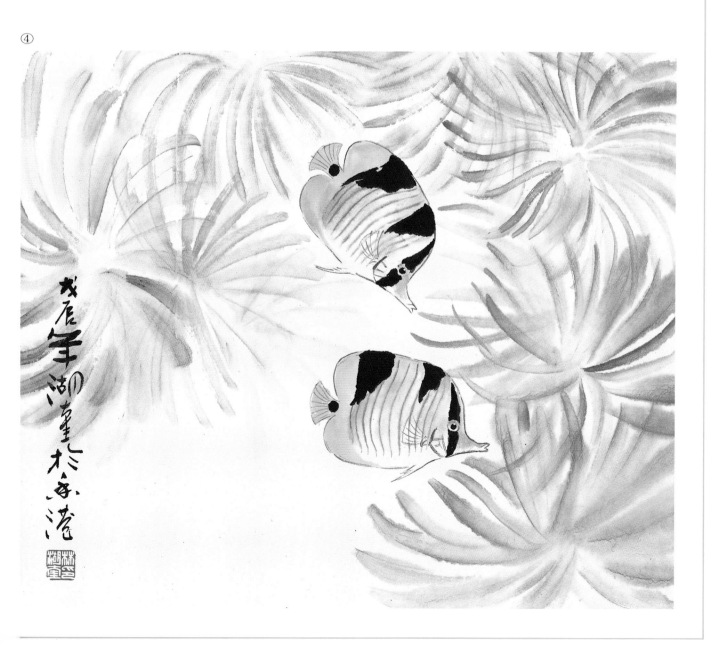

五彩神仙魚

Discus

五彩神仙魚是熱帶魚，五彩繽紛的魚身上加黑斑紋，在漂動水草中嬉游，像彩蝶間穿梭花葉間，非常美麗。

①先構圖。以中鋒筆鉤出輪廓，再寫墨斑紋。

②淡水五彩神仙魚之顏色複雜，品種亦多，寫時選顏色簡單，多斑紋者為佳。着色以淺淺雅樸為上。

③以毛氈墊底後噴濕畫面。先用羊毫筆寫水草。以花青加少許墨和綠色，調勻後用排筆染上。留水光以畫出水的動感。

④題字蓋章完成。

These fish arranged in a same row look like three soldiers strictly and monotonously. Changing the position of one of them will add to the visual variety.

(1) Draw the outlines of these fish.
(2) In application of colors, one should notice to use light and mild pigments and show the gradations of tonality.
(3) Cushion the paper and spray the picture. Draw the sea water with three varied colors.
(4) Put the incription and seal on.

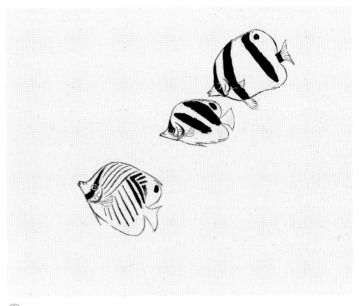

①

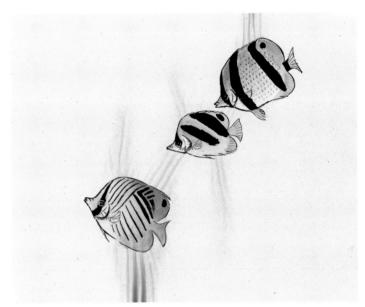

②

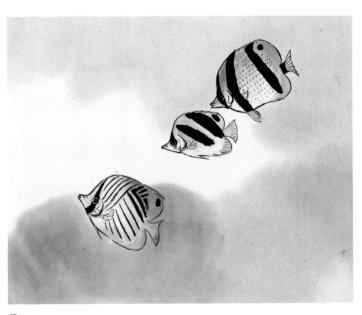

③

④

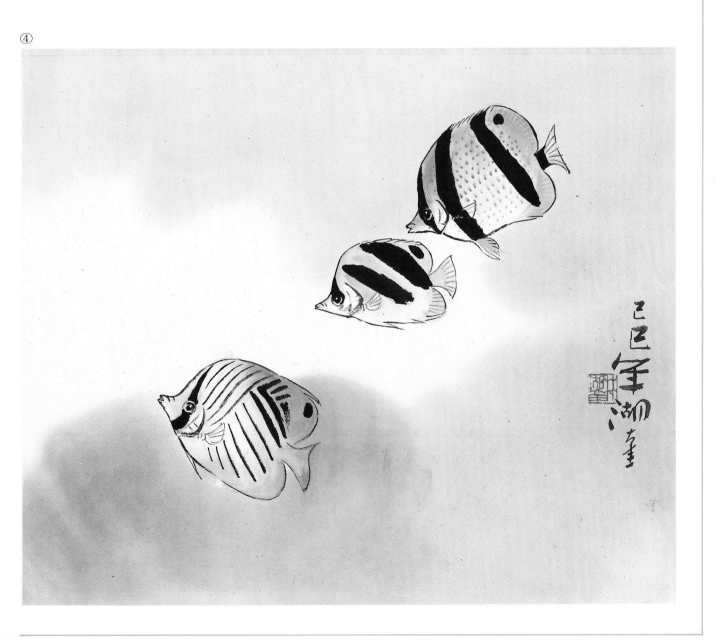

The Plates
作品欣賞

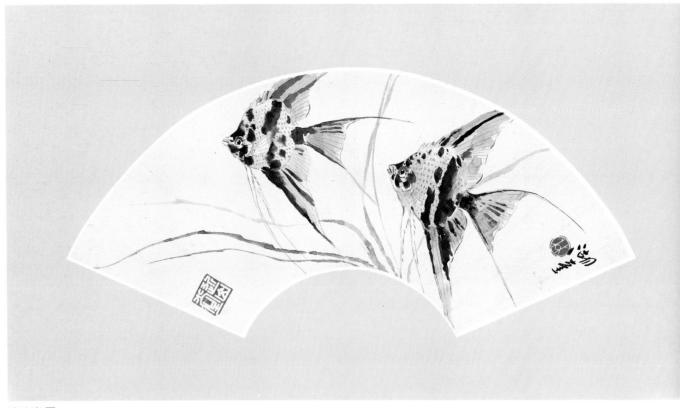

神仙脊屬
Happy Couple

追逐
Chasing

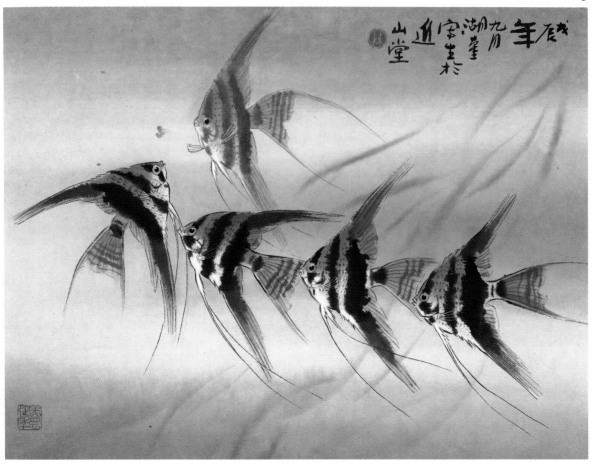

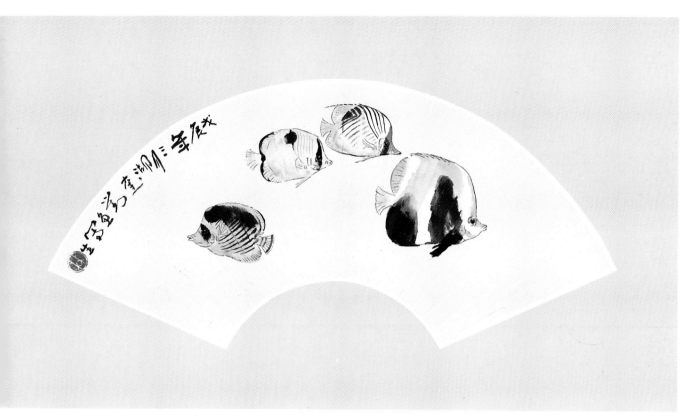

四不圖：不思、不慮、不憂、不樂
Four Negative

高手相逢
Meeting Between the Masters

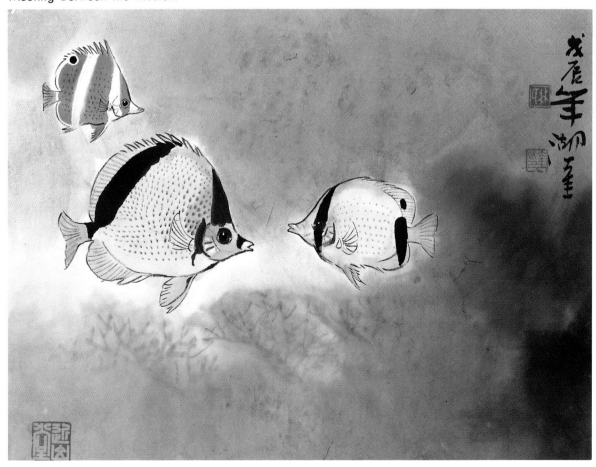

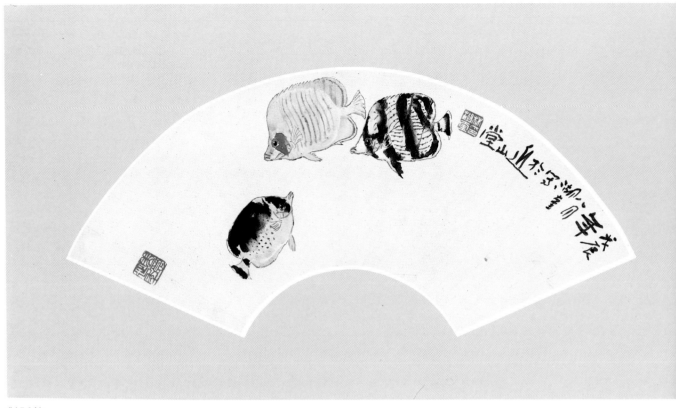

對話錄
The Converbation

紅珊遊
Through the Red Coral

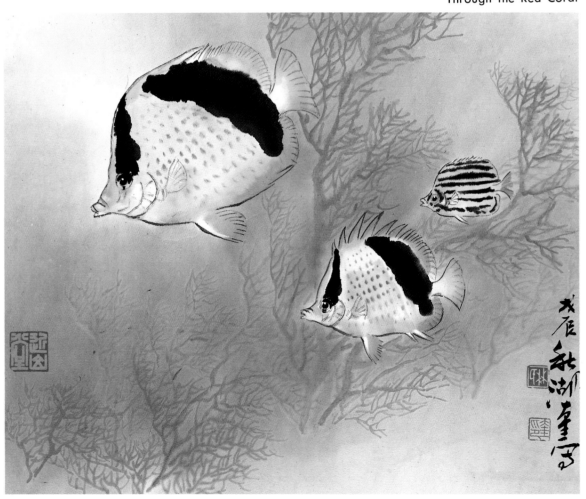

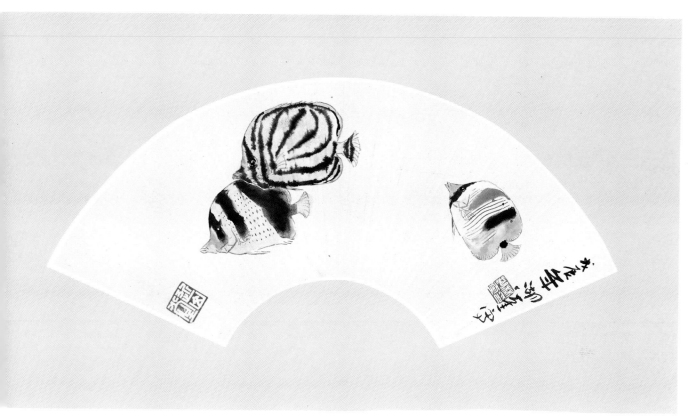

潛居
Hermitage

郊遊樂
A Delightful Outing

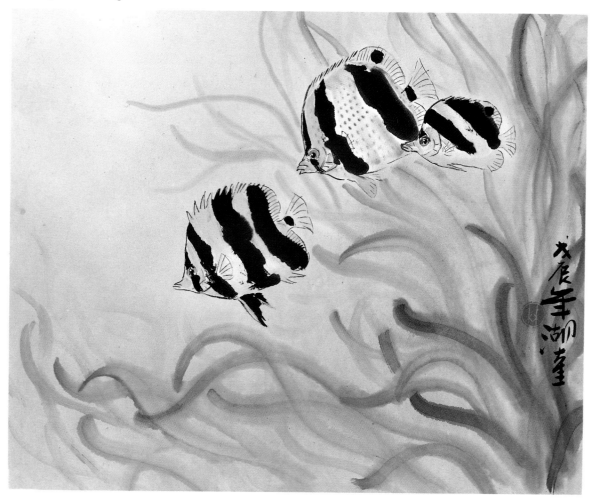

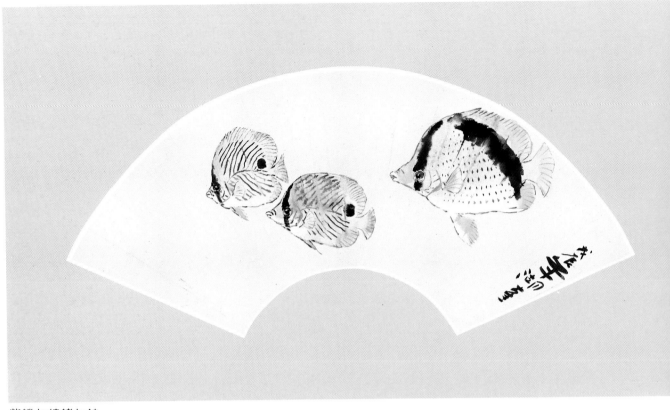

紫鱗如繡鰭如錦
Colorful Clothes

瀟湘波動共沈浮
Under the Waves

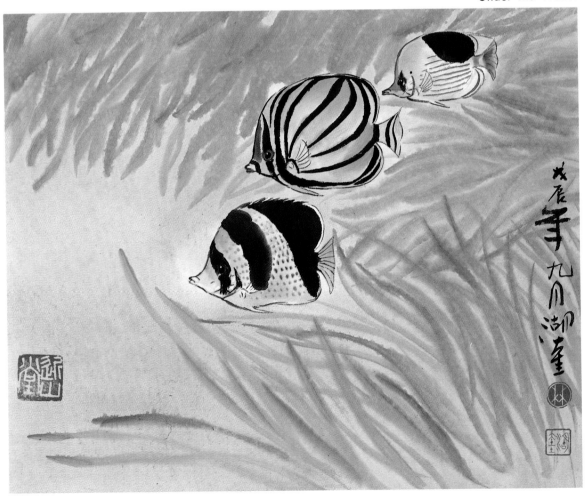

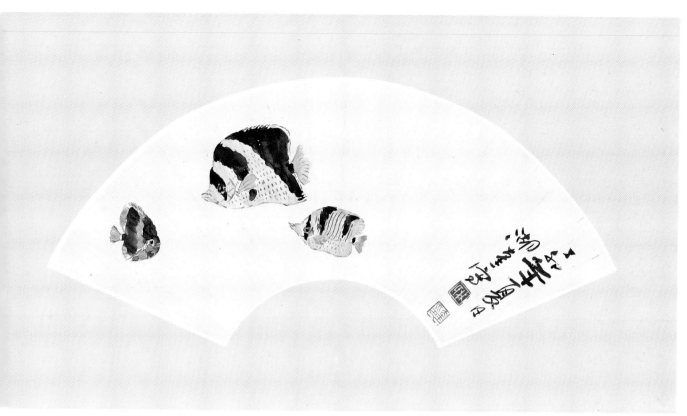

魚語
They talk！

擦肩而過
Passengers

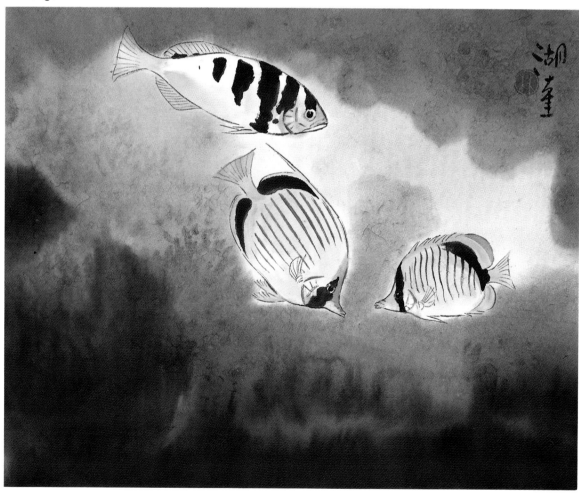

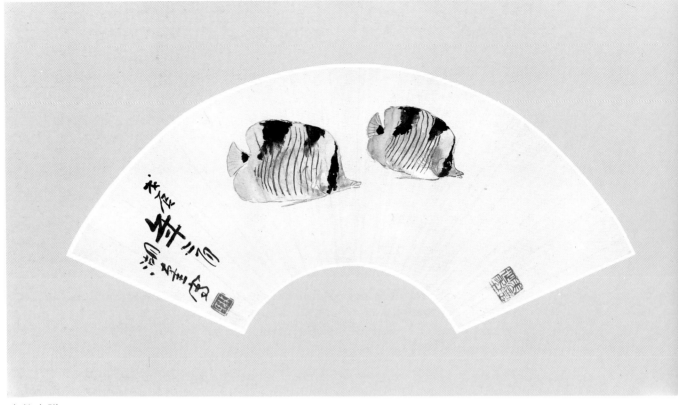

意態安詳
At Leixure

幾何圖
The Geometrical World

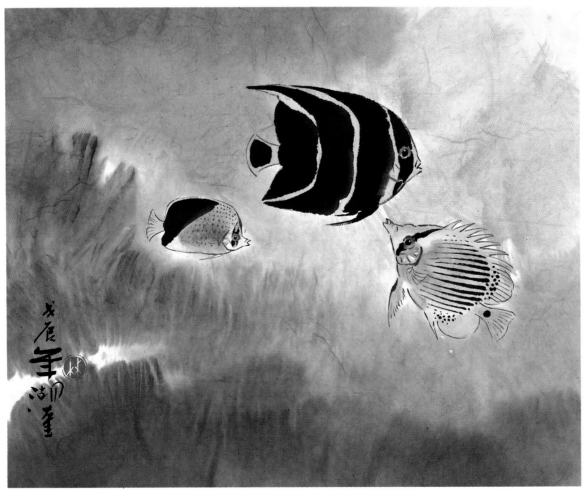

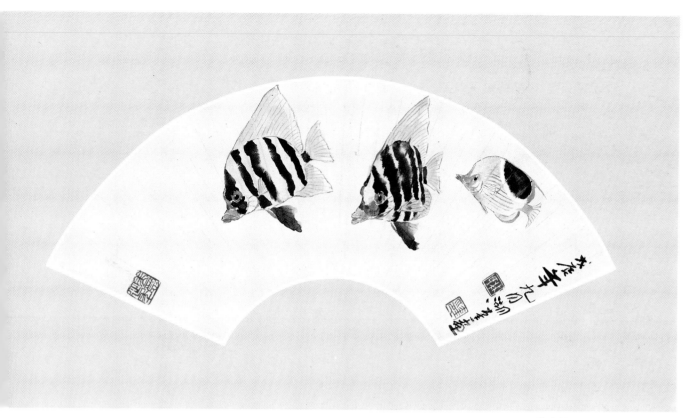

兼容異己
To Submit the Difference

針鋒相對
Opposing

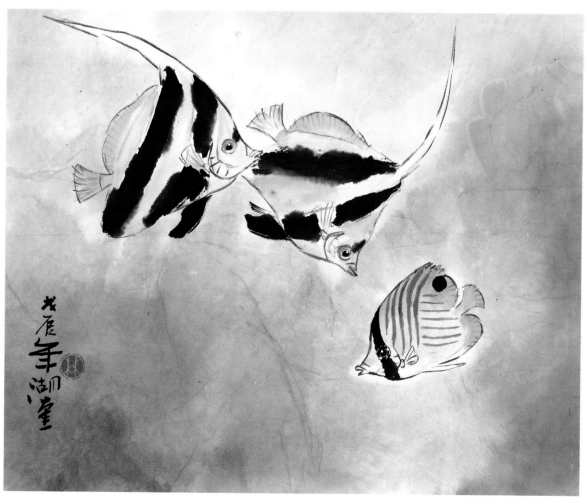

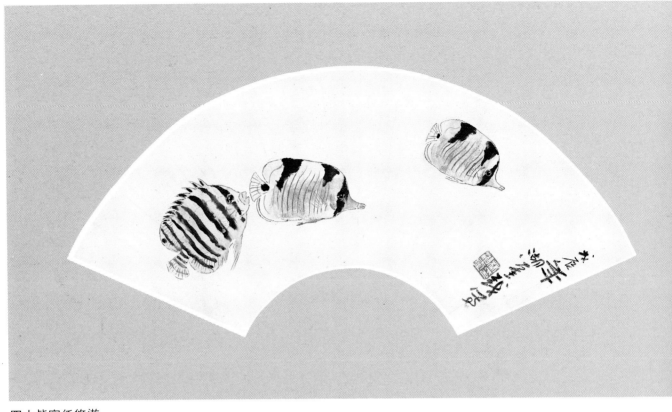

四大皆空任悠遊
Swimming

深海無晴陰
A Calm Day

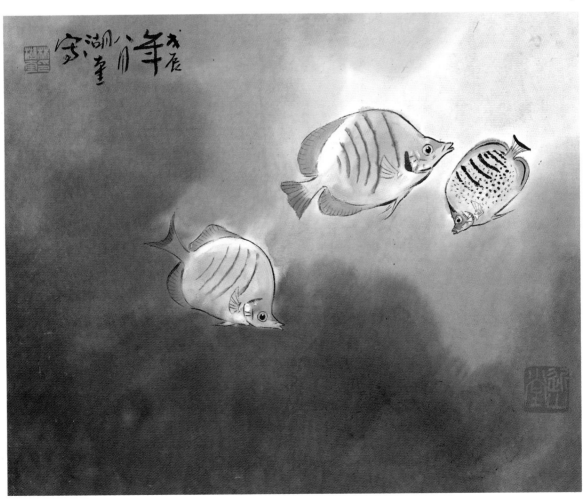

82

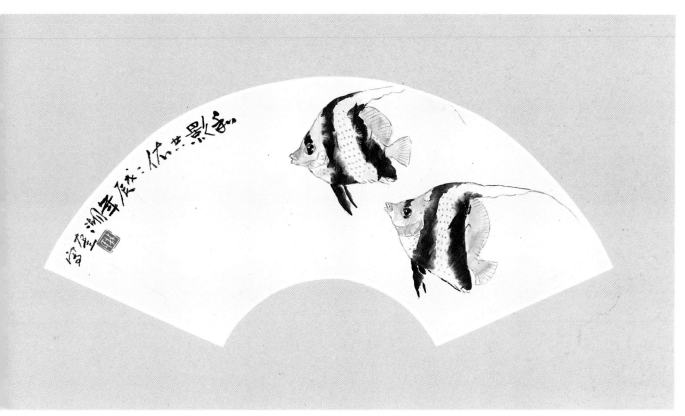

夫唱婦隨
Sweet Heart

魚戲圖
For Fun

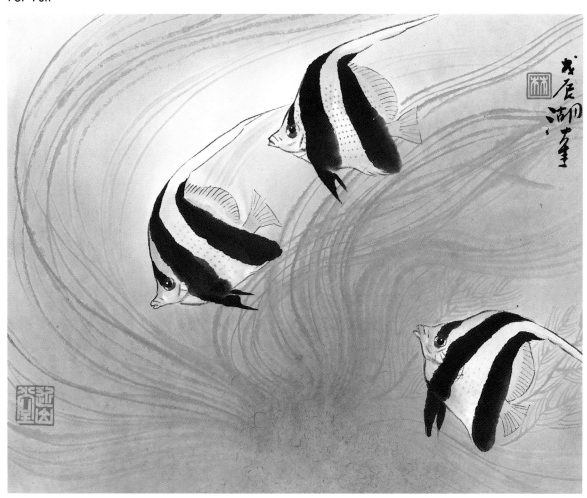

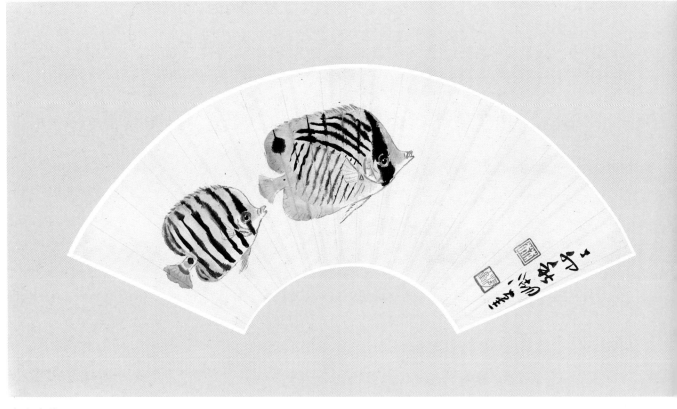

亦步亦趨
Never to Apart

隨我！隨我！
Follow Me

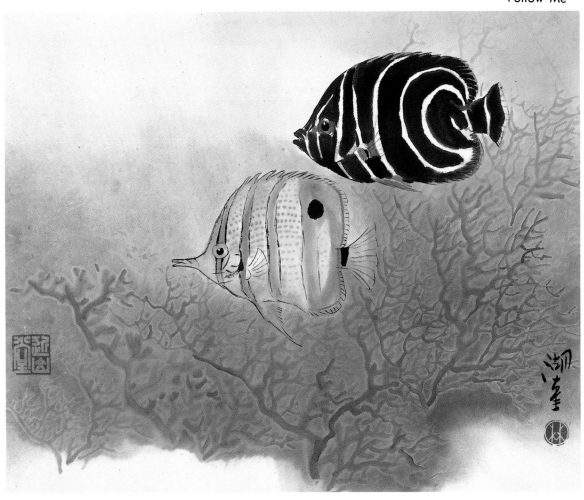

84

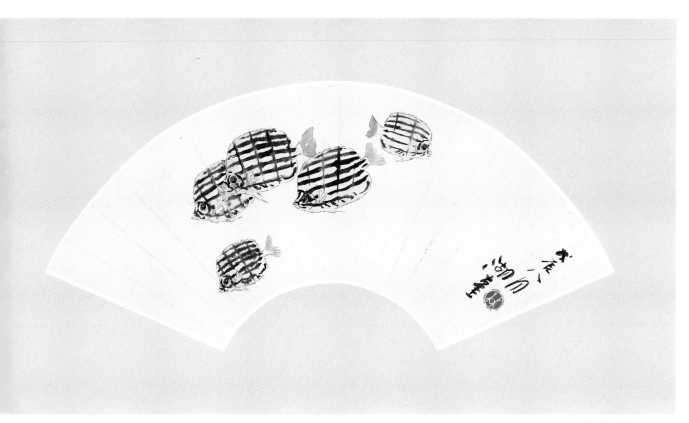

卓然不群
The Lone Ranger

身披彩虹裳
The Rainbow Clothes

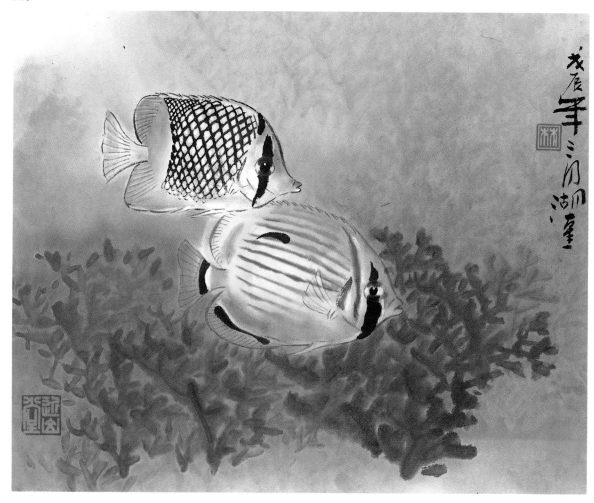

倩影
Shadows

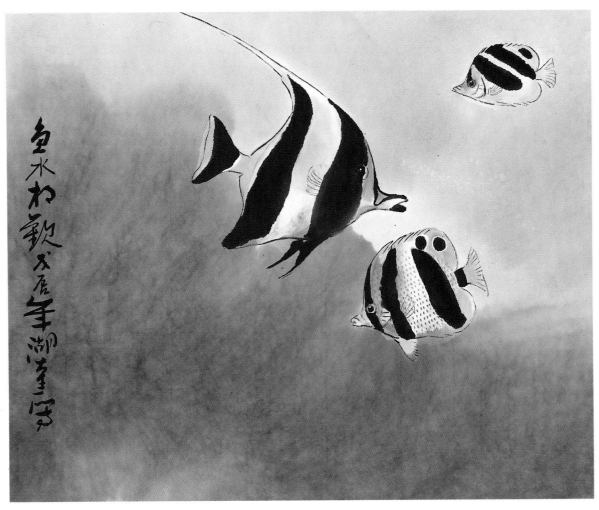

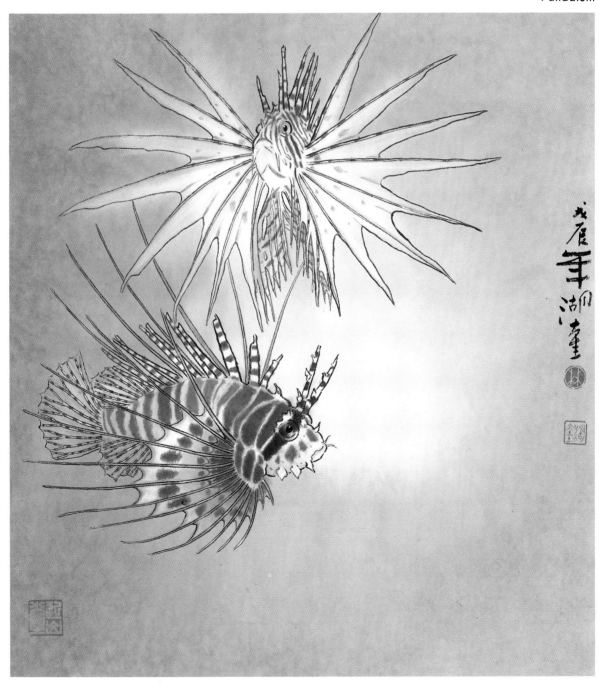

喁喁蜜語
Whispering

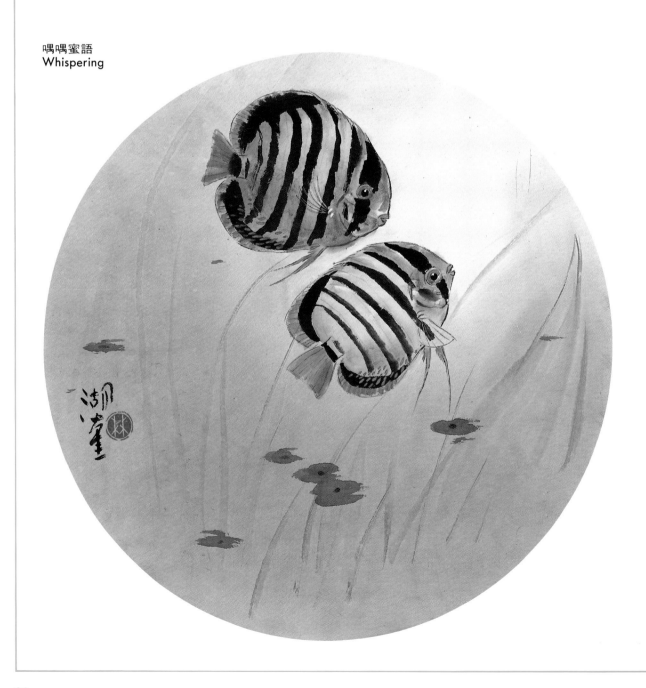

此時無聲
Silence

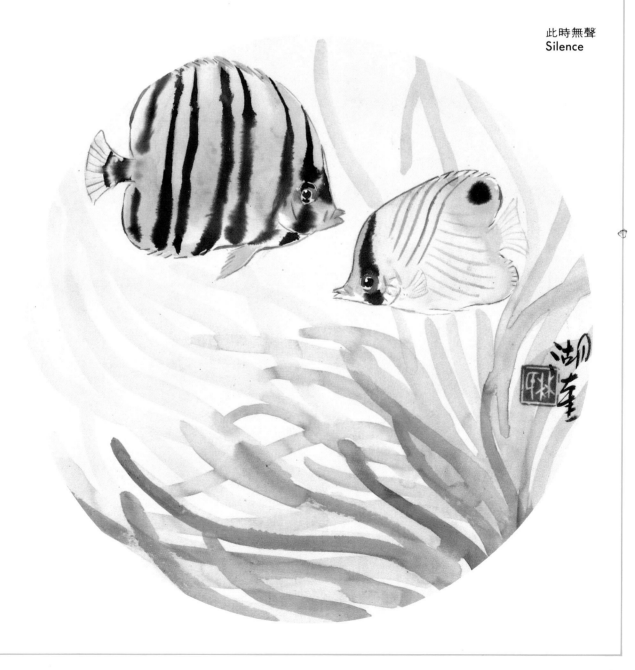

緣圓圖
A Couple

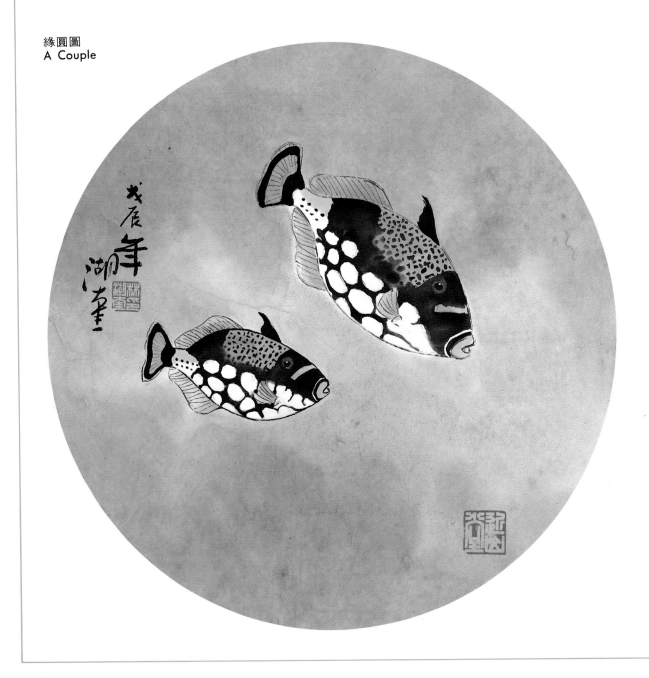

蟄
In the Deep

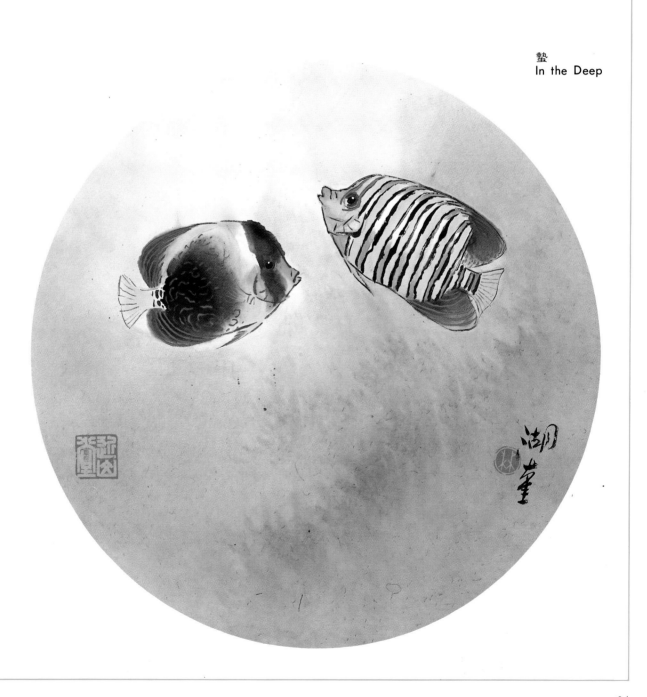

劍舞
Sword Dance

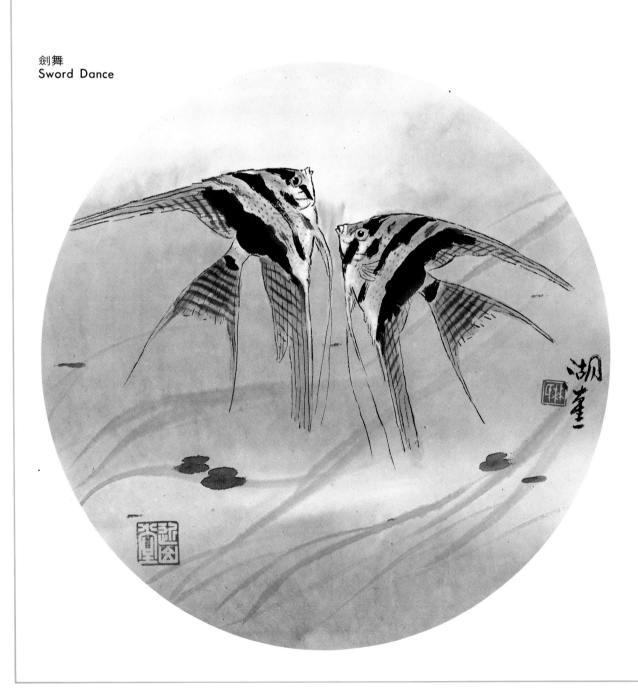

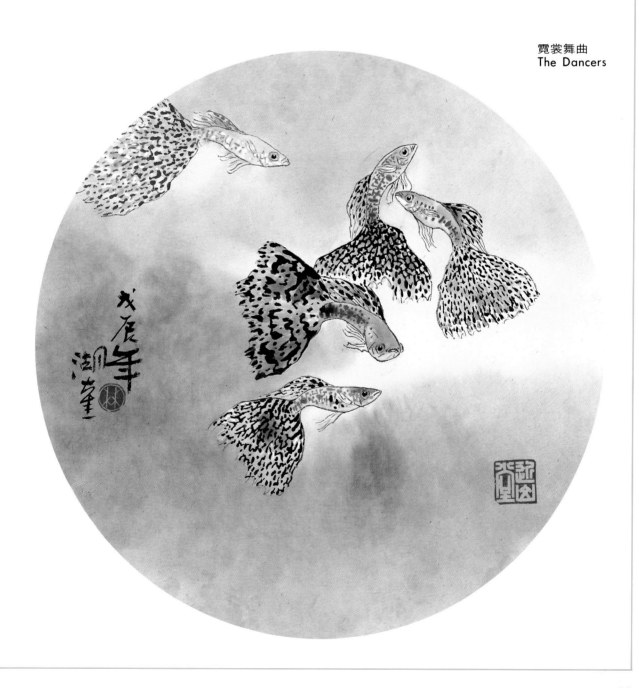

霓裳舞曲
The Dancers

海深情何逸
Deep Affection

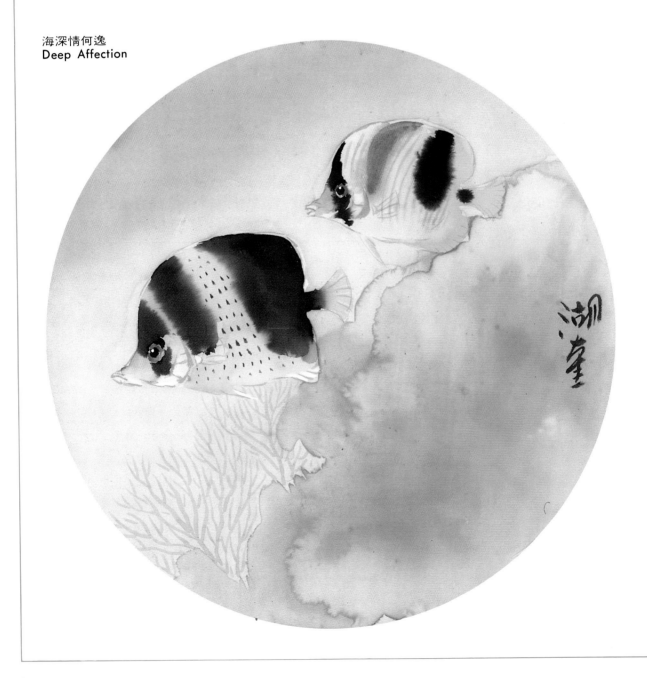

追尋
Following

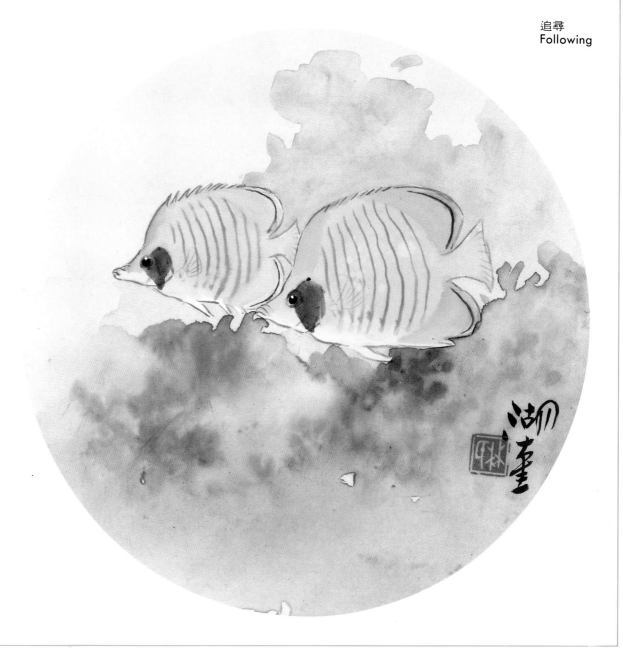

古今但冥冥
The Darkness

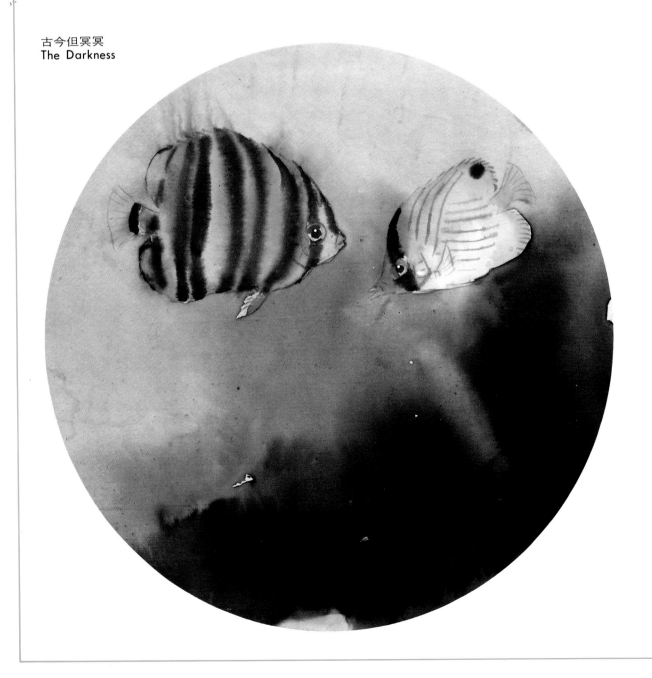

身托波流共一生
Be Together

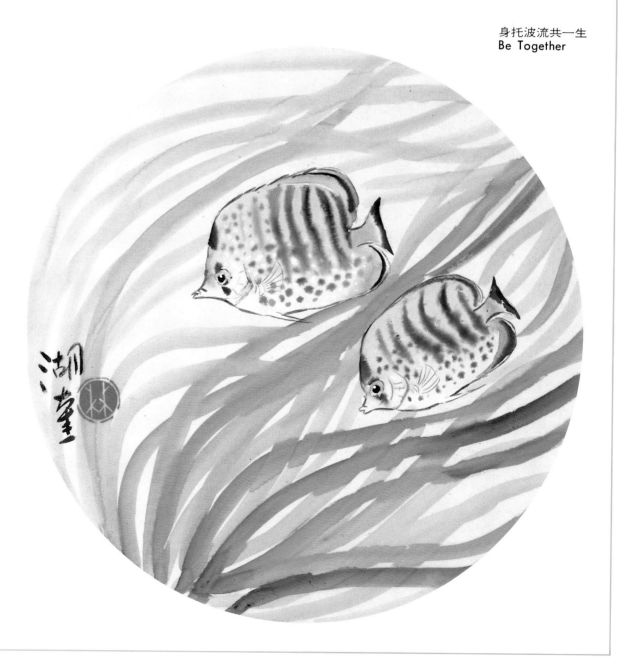

且此徘徊
Lingering

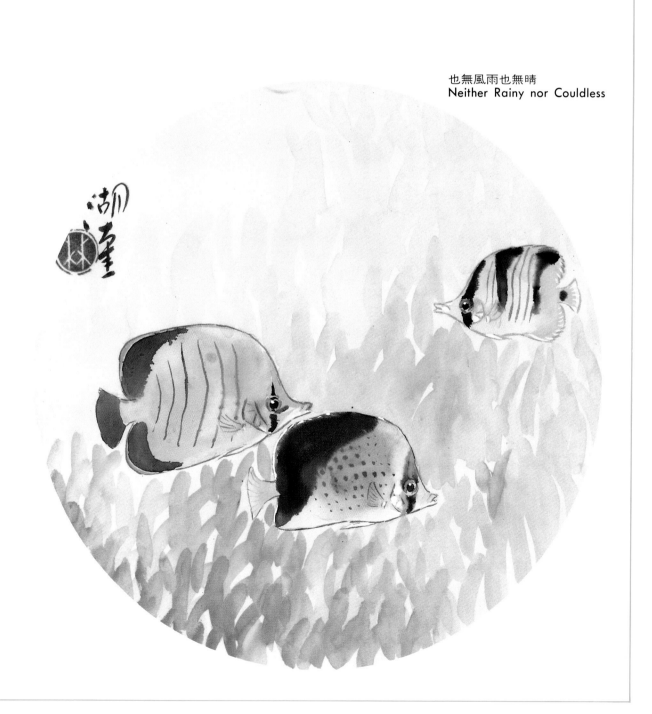

也無風雨也無晴
Neither Rainy nor Couldless

斑斕海色
Colorful sea

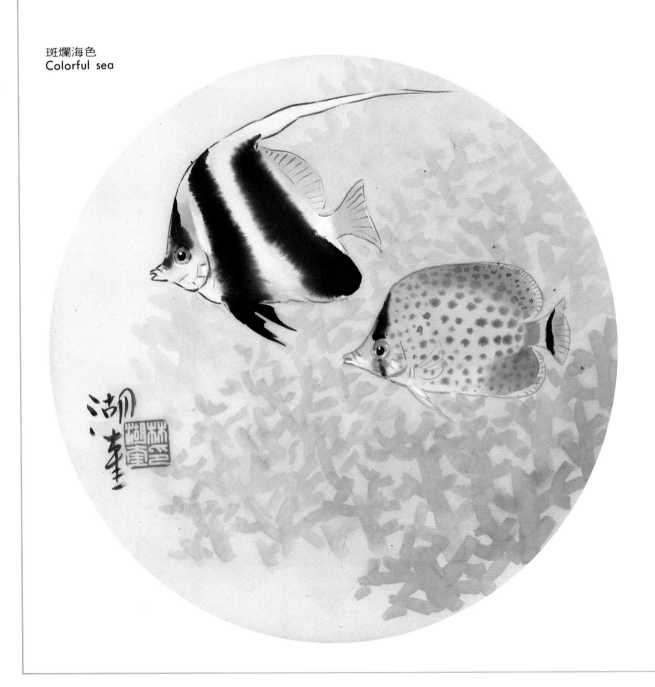

草上遊魚
Upon the Water Plants

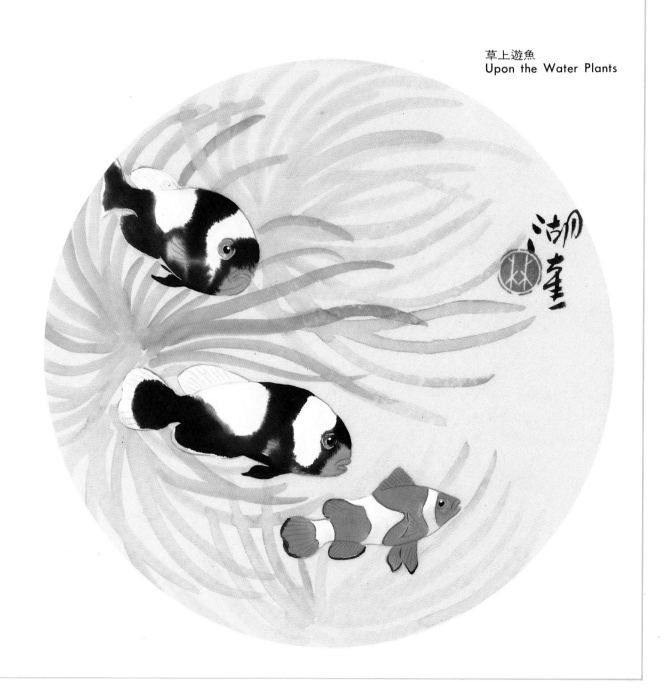

噫！
Eh！

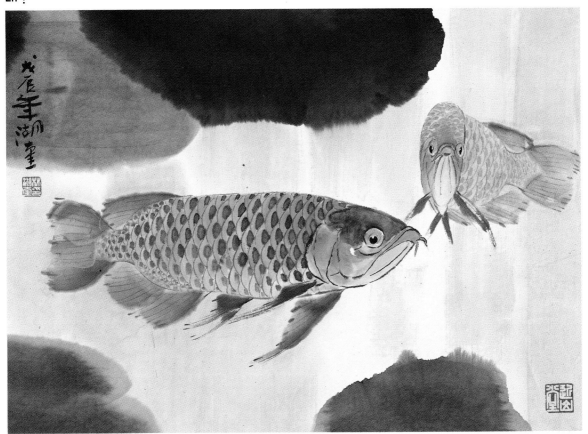

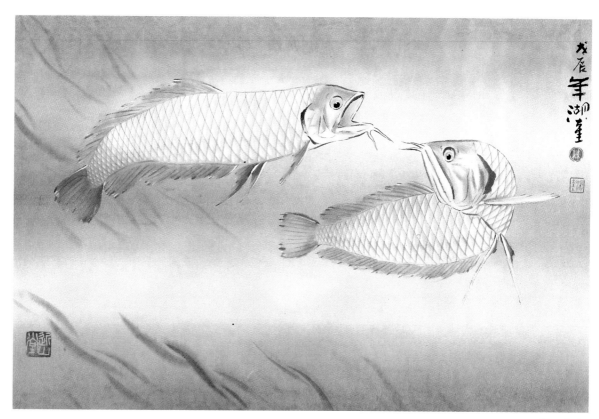

怒目相視
Arguing

逍遙遊
A Carefree Time

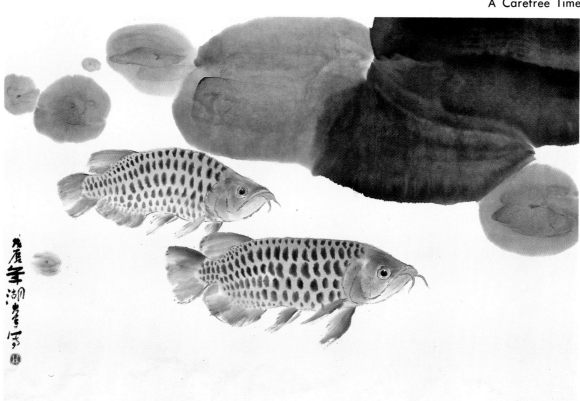

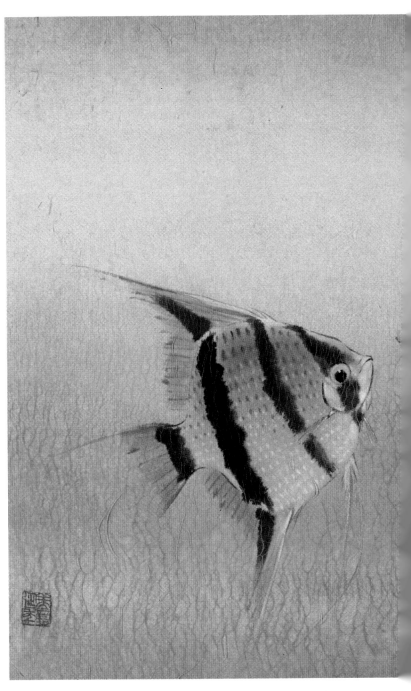

群居樂
A Happy Group

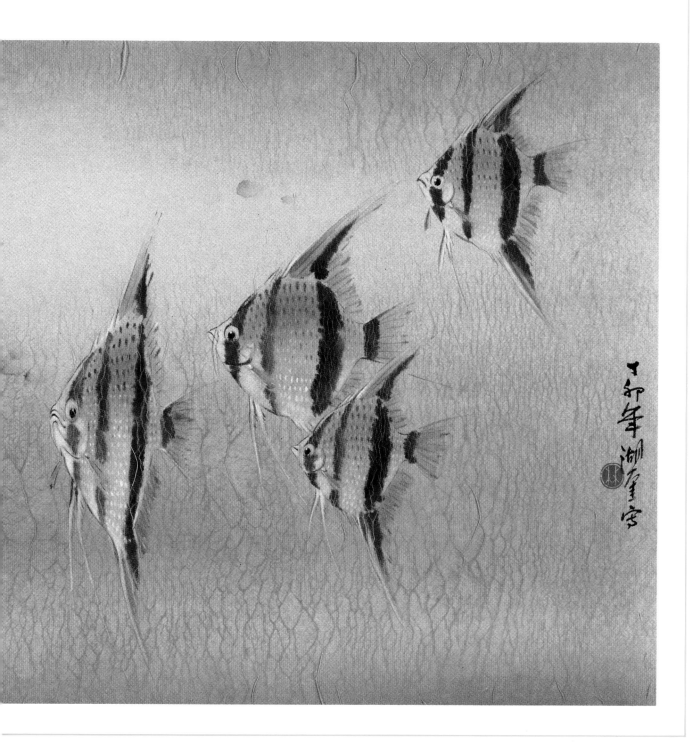

沉靜
Stillness

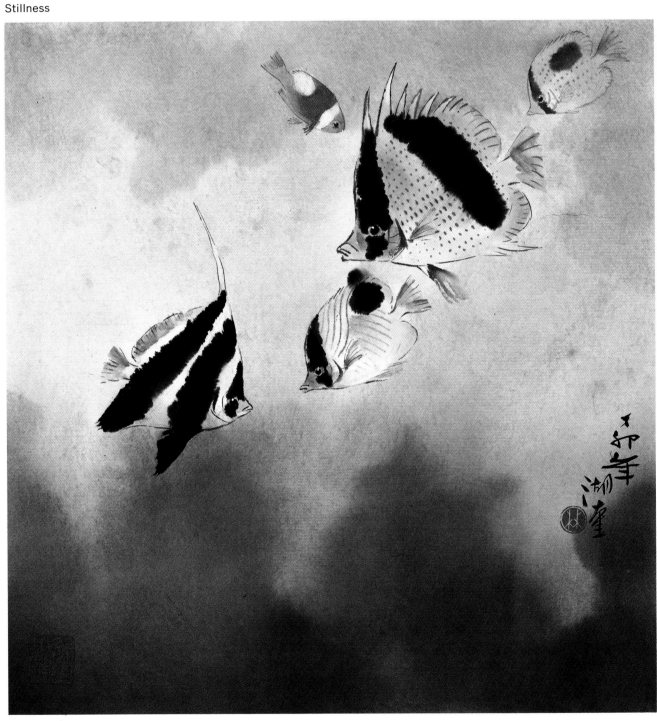

殊類同途
In the Same Direction

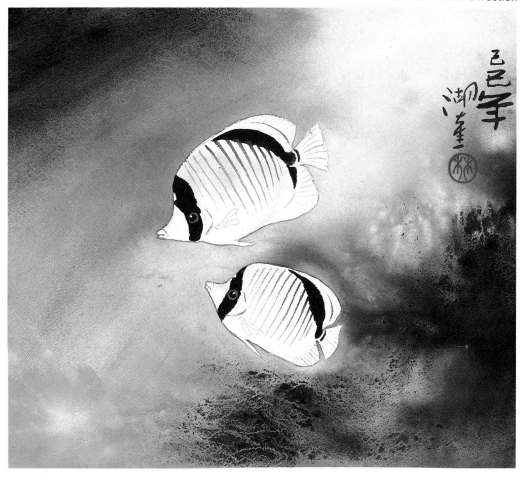

群樂圖
A Coteria

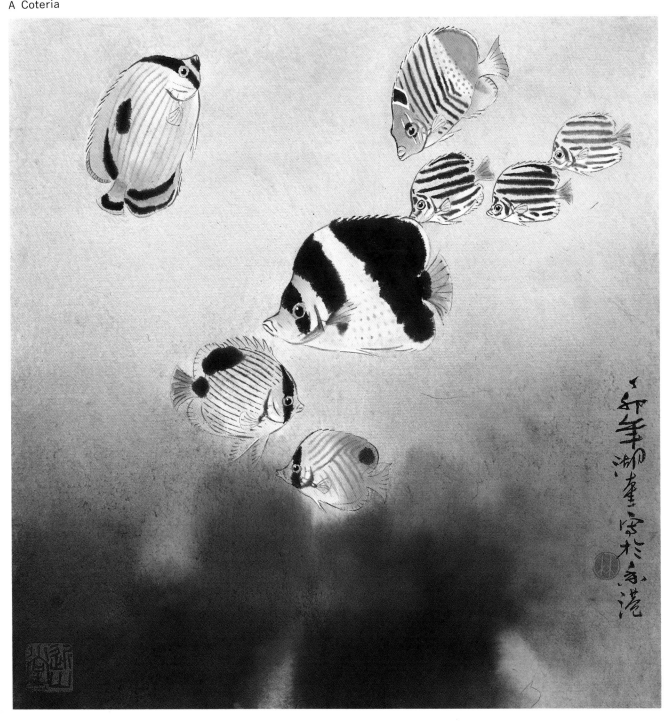

大智若愚
The Wise Looks Dumb

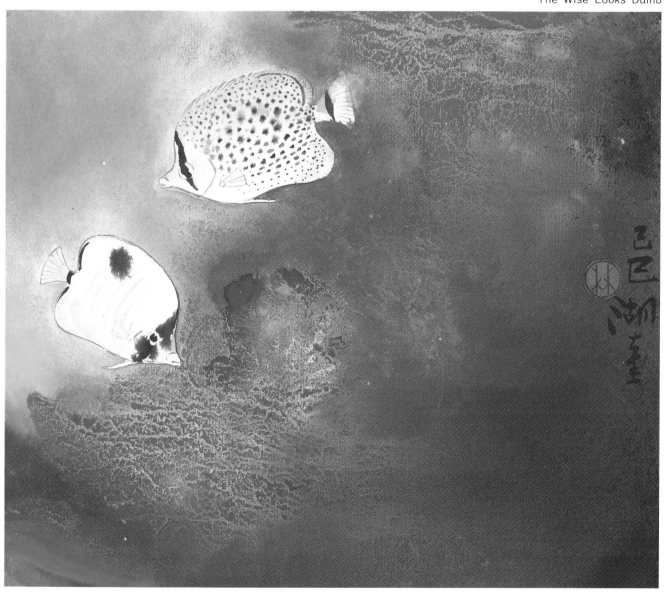

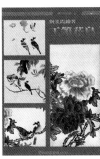
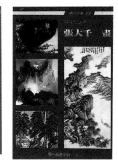

5001. 金魚 錦鯉
林湖奎繪著

林湖奎以清麗自然的筆調，繪出了金魚和錦鯉可愛的風貌。從個體與組合的基本技法到作品欣賞，本書教您如何畫好國畫！

Goldfish and Golden Carps
By Lin Hu-kuei

How to paint goldfish and golden carps with their various appearance in group or alone. This album shows the basic skills of all these.
30×21 cm. 110 pp. 6 b&w, 92 full-color illus.
Chinese/English in full-color

5002. 畫荷花
何恭上主編

是大師們畫荷經驗的薪傳明鏡。張大千、趙少昂、楊善深、吳學讓、趙松泉、蘇峰男、伍揖青等大師的繪荷技法，舉凡寫意、彩墨、嶺南、海派、工筆、寫生……在本書系統性的分門別類之下，引導您走向清香的國度。

Drawing Lotus
By Ho Kung-shang

7 of the contemporary great masters, guide selflessly through styles which they are good at, in order to help the beginners rendering this beloved theme in easy ways as well as provide choices of drawing lotus.
30×21 cm. 134 pp. 1 b&w, 124 full-color illus.
Chinese/English in full-color

5003. 荷之藝
何恭上主編

「予獨愛蓮之出淤泥而不染，濯清漣而不妖……」您也愛蓮嗎？本書分九種畫法，集了近五十位世界當代荷花傑作，如齊白石、陳之佛、溥心畬、劉海粟、喻仲林、程十髮……一場難得的風雲際會；您若愛蓮，必然陶醉其中。

Art of Lotus
By Ho Kung-shang

Nearly 50 artists from the world of 9 various schools, show their eminent lotus paintings in this album.
30×21 cm. 135 pp. 7 b&w. 121 full-color illus.

5004. 走獸畫法
李奇茂繪著

當代走獸名畫家李奇茂先生，利用其敏銳的觀察力將習見動物如牛、馬、鼠、兔……生動地展現眼前，並分析其畫法。

Elementary of Beast Painting
By Lee Ch'i-mau

The most important things for beast painting are to paint out the eyes and their active movements. Lee shows the ways to achieve these purposes. The beasts included horse, cow, rabbit etc.
Chinese/English

5005. 工筆畫法
劉玉霞繪著

劉玉霞繼承了其師喻仲林「以工筆為形，以寫意為骨」的特長，適切掌握了畫筆下各種主題的氣質。本書示範以筆為主，初學者可經由詳細的指導步驟，體會琢磨出工筆畫之美。

Elaborated Style of Chinese Paintings
By Liu Yi-shia

Liu inherited the skills of the elaborated style from Yi Chung-lin, a very famous painter. Now, insteadly, she is teaching the beginners how to paint in detail demonstrations.

5006. 工筆花鳥
劉玉霞繪著

十五年習畫的經驗，在本書中傾囊相教，劉玉霞讓您在追求細膩、精緻、富麗、典雅的大道上免去許多冤路。共分花卉、禽鳥、草蟲三部，教您如何在小小畫幅中，創出意韻無窮的天地。

Elaborated Style of Flower & Bird Paintings
By Liu Yi-shia

Sketching, forming, coloring····Liu guides in a systematic way through her 15 years experience of painting in elaborated style. A must for the beginners.

5007. 花卉畫入門
喻仲林繪著

本書收集了喻仲林在課堂上為學生而示範的花卉畫稿，讓習畫者有機會在幾十年後的今天，沐浴在大師循循善誘的春風裡，循階而上，將花卉畫拓成一片蓬勃的天地。

Elementary of Flower Painting
By Yu Chung-lin

Strictly select from Yu's 2,000 manuscripts, we have 200 of his demonstration maunscripts which he painted at U. of Hawaii when he taught there. A special guidance for this populor subject.
21×30 cm. 160 pp. 280 full-color illus. 30,000 words.
Chinese/English

5008. 翎毛畫入門
喻仲林繪著

喻仲林有三十餘年花鳥畫經驗。其翎毛畫的特色是設色明麗，風致天然，繁而從簡，艷而能清。本書特選出適合初學程度的畫稿，深入淺出的向您介紹各種鳥類的畫法。

Elementary of Bird Painting
By Yu Chung-lin

With over 30 years of bird painting experience, Yu had accomplished an excellent achievement. Here is the demonstrations of his brushing method, his keen observation of the spirit of bird with detail interpretations.
Chinese/English

5009. 嶺南派畫法(一)
通論・花卉・蔬果
盧清遠繪著

嶺南畫派，融合了西洋繪畫所強調的光影技巧。本書先概括地介紹嶺南派的繪畫特色；繼以花卉、蔬果畫法示範。是嶺南派畫法入門必備之書。

To Paint in Ling-nan Style (1): Theories, Flowers, Vegetables
By Lu Cheng-yuan

First, this book introduces the theories of the Ling-nan school. Follows by 9 methods of drawing vegetables. A must for entering the Ling-nan school.

5010. 嶺南派畫法(二)
草蟲・鳥雀・游魚
盧清遠編繪

草蟲、游魚、鳥雀是嶺南畫派最擅長表現的題材，小小的生命，處處向人展現生的喜悅。除了畫法示範，尚附有每種生物的分析圖，以及多位名家的例圖。

To Paint in Ling-nan Style (2): Insects, Fish, Birds
By Lu Cheng-Yuan

This 3 items are the most popular subjects for the Ling-nan school painters. There are detail demonstrations, biological analysis diagrams for each item and many masterpieces as reference.

5011 嶺南派畫法(三)
山水・人物・走獸
盧清遠編繪

嶺南畫派的山水、人物、走獸畫法，從日本畫技法滲入西洋畫的色彩，而展現出所謂的嶺南風，它的技法是如何呢？本書不但有例圖，也詳細分解、示範。

To Paint in Ling-nan Style (3):
Landscape , Figure , Beast
By Lu Cheng-Yuan
Influenced by Japanese and Western painting technigues, the Lin-nan school appeared in its very own style. Learn it through this book, you'll find the answer.

5012. 張大千　畫
張大千繪著

張大千是這個時代的畫壇巨人。高嶺梅跟隨大師多年，本書的畫論、畫法、畫範，便是他一點一滴所滙集而成。這第一手資料，實不容錯失！

Chinese Painting
By Chang Da-Chien
Chang, the greatest Chinese artist of the century. This album performs you his talent in this particular field. His profound theories help to know more about Chinese painting, too.
21×30 cm.　168 pp.　20 b&w, 160 full-color illus. 50,000 wards.
Chinese/English

5013. 寫意畫花
于希寧繪著

于希寧的寫意畫用筆簡逸，濃淡適宜，線條如行草飛舞。他把紅梅、白梅、菊花、紫藤、芍藥、牡丹、石榴、枇杷、絲瓜、凌宵等十種主題，每種選一幅畫以示範表現，並附數幅例圖供參考。
中英對照・120 p・彩色印刷。

Flower Painting in Spontaneous Style
BY Yu Hsi-ning
Detailed steps guiding of painting red and white plum blossom, chrysanthemum, wisteria, peony, paeonia, pomegranate, loquat, sponge gourd etc.
Yu's succint style of lining subjets is the echo of melody, simple but attrative.
Chinese/English 128 p in full-color

5014. 海水魚・熱帶魚
林湖奎繪著

海水魚、熱帶魚每個家庭都非常喜歡飼養，欣賞之餘拿筆描繪，也是件賞心悅目的事。本書把各種海水魚與熱帶魚畫法，以個體、組合與作品欣賞三單元來介紹。
中英對照・112 ρ・彩色印刷。

Drawing Sea Fish and Tropical Fish
By Lin Hu-kuei
Contents of this book are divided into three sections. Section 1 is the steps guidance of lining and coloring. Section 2 is the steps guidance of the arrangement of composition. Lastly, the plates of the auther.
Chinese/English 112 p in full-color

5015. 畫小鳥
楊鄂西繪著

楊鄂西教授繪的鳥雀，姿勢靈活，不但注意鳥性，也注入人性。她選擇麻雀、白頭翁、黃鸝、紅山椒、綉眼、文鳥、冠羽畫眉、翠鳥、燕子九種生活在人們周邊的小鳥，是本易解易學的鳥畫入門書。
中英對照・128 p・全部彩色。

Drawing Little Birds
By Yang O-shi
The birds painted by Yang, are not only the forms and movements, but she has also filled in her very own emotion to personification them. Follow the instruction of her how-to-paint, you will soon paint out your own style of sparrow, bulbul, oriole, swallow……etc.
Chinese / English　128 p in full-color

5016.　畫馬
許勇・白素蘭・陳永鏘繪

從工筆畫馬方法、寫意畫馬方法、單馬畫法、雙馬畫法、群馬畫法、馬和騎師畫法、馬的頭部、馬的軀幹到馬的運動，以各種技法，各種表現法，指引畫馬之技藝。

Drawing Horses
By Shi Yong, Pai Su-lai, Chen Yong-chiang
How to paint single horse, double horses, group horses, rider and horse and their movements in elaborated and expressive styles. Diagrams and illustration of the detailed parts such as head and body are added to help the beginners for a better understanding.
Chinese/English　in full-color

5017.　畫樹寫林
盧錫烱編繪

在山水畫中，怎樣把樹畫好是非常重要的，當樹如人，稍不合理，如不全之人也。畫樹之功，居諸事之半。尤其山水畫，獨樹或林，都是最重要的。

Drawing Trees
By Yang Si-chiong
Trees play an extreme important role in landscape painting, similar as flesh to the body. Begin from the trunks, branches, then roots and leaves, Yang guides you to complete various kinds of trees. To move further ahead, he shows you how to composite them with lot of examples.
Chinese/English　in full-color

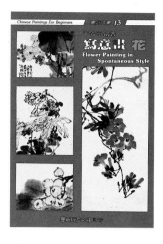

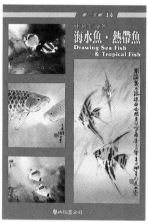

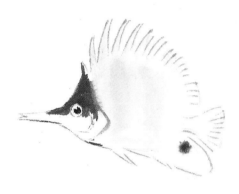

畫好國畫 **14**

海水魚・熱帶魚

林湖奎編著

法律顧問◉	北辰著作權事務所	
◉	蕭雄淋律師	
發 行 人◉	何恭上	
發 行 所◉	藝術圖書公司	
地　　址◉	台北市羅斯福路3段283巷18號	
電　　話◉	(02) 362-0578・(02) 362-9769	
傳　　眞◉	(02) 362-3594	
郵　　撥◉	郵政劃撥 0017620-0 號帳戶	
南部分社◉	台南市西門路1段223巷10弄26號	
電　　話◉	(06) 261-7268	
傳　　眞◉	(06) 263-7698	
中部分社◉	台中縣潭子鄉大豐路3段186巷6弄35號	
電　　話◉	(04) 534-0234	
傳　　眞◉	(04) 533-1186	
登 記 證◉	行政院新聞局台業字第 1035 號	
定　　價◉	480元 特價書不退換	
再　　版◉	1998年 4 月28日	

ISBN 957-672-270-5